THE SHADOW OF JAMES JOYCE

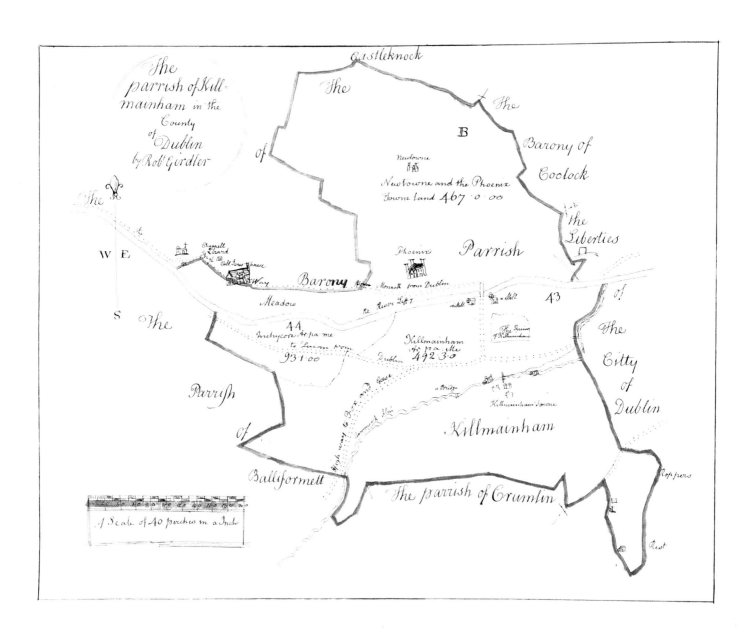

The parrish of Kill-mainham in the County of Dublin by Robt Girdler

Castleknock

The

Of

B

Newtowne

Newtowne and the Phoenix Towne land 467 : 0 : 00

The

Barony of Coolock

The

the Liberties

The

W E

S The

Phoenix

Parrish

Chappell Izard
Coll Fors house

Barony

Way

Meadow

Honnott from Dublin

The River Liff 1

a Mill

a Mill

43

Of

Inchycore At pa me
to Lucan from
931 00

44

Killmainham
At pa Me
492 3 0

Dublin

The Ruins
of Killmainham

The
Citty
of
Dublin

Parrish

Of

Ballyformett

High way to York and Goose

a Bridge

Killmainham Towne

Killmainham

The parrish of Crumlin

Roppers

Rest

A Scale of 40 perches in a Inch

THE SHADOW OF JAMES JOYCE

CHAPELIZOD & ENVIRONS

David,

Congratulations on your 70th birthday.
and best of luck from here on.
I hope you will enjoy my book, I'm
sure you will!

2011年 6月

First published 2011 by
THE LILLIPUT PRESS LTD
62–63 Sitric Road, Arbour Hill, Dublin 7, Ireland
www.lilliputpress.ie

FRONTISPIECE
The Parrish of Killmainham in the County of Dublin by Robt Girdler in the *'Down Survey'*
This map is one of many carried out in the *'Down Survey'* of 1655-56 under the direction of Sir William Petty
following the Cromwellian conquest of Ireland. Like this map featuring Chapelizod ('Chappell Lizard')
and Phoenix Park along the Liffey, the *'Down Survey'* maps noted townland boundaries, houses, castles, roads,
rivers and fields and included accounts of previous landowners, their religious affiliation, and the lands' valuation and acreage.
(This manuscript is from the National Library of Ireland's Map Collections, MS 714, 16.)

© Ordnance Survey Ireland/Goverment of Ireland
Copyright Permit No. MP 000211

ISBN 978 1 84351 193 9

1 3 5 7 9 10 8 6 4 2

Set in 11.5 on 14pt Garamond
Design by Elizabeth van Amerongen
Printed and bound by Grafo, Basauri, Spain

CONTENTS

『ジェイムズ・ジョイスの影版を祝って

　このたび待望の藤田需子さんの見事な写真集が出たことは、まことに嬉しいことだ。藤田さんは我々の大学、梅光学院（当時は女学院）の大学院出身だが、在学中、学校が招いたあるすぐれた文学者の講演を聴いた時、内なる不思議な意欲が目覚めたという。以来独自の文化的活動を続け、やがてアイルランドに渡る。こうして、アジアとヨーロッパの両大陸を超えて、極東の島国から極西の島国へと赴いた。やがて家庭も持ち、念願の写真家の途を目指す。

　藤田さんはすごく意欲的でエネルギッシュな人だが、写真はあざやかな映像を作る以上に、人間存在そのものの内面に迫るものでなければなるまい。絵画で言えばセザンヌのような、まっとうな生き方こそが大切だ。そんなことをある時、ジャコメッリという写真家の作品を見ながら語りあったものだが、この時もまた、ひとつ眼が開いたと言っていた。

　こうして出来たこのたびの写真集は、ジョイスという作家の足跡を切り口に、アイルランドの歴史の跡を辿っているが、すべてがモノクロの映像で、そこにはヨーロッパ文明にまるごと染まらぬ、アイルランド独自の文化と歴史の跡が見事に見えて来る。モノクロの世界こそは人間であれ、自然であれ、その存在の独自の深い陰影をにじみ出させるものであり、またこれを映す人の心の奥の、抑制された中にこもる熱い情熱と想いもつたわるものである。

　この写真集には同じ島国であるが故に、アイルランドの独自の伝統美に魅かれる、作者の実感がにじみ出ている。そこにはまたイエイツのようなすぐれた文学者の影も感じられる。私もダブリン郊外にあった古い日本式庭園に遺っていた楓の古木を映した作品を研究室に飾っているが、たしかに心しずまるものがある。

　藤田さんは様々な精力的な活動の中で、今も我々の大学梅光とダブリンの大学との交流のためにも熱心な活動も続けている。とまれ、写真にもアイルランド文化にもうとい筆者だが、このすぐれた写真集の独自の魅力には心惹かれるものである。ひと言お祝いの言葉を申し上げ、これが多くの人たちの眼にふれることを心から願うと共に、作者藤田需子さんの一層の成長、成熟を心から願うものである。

<div align="right">梅光学院大学　客員教授　佐藤泰正</div>

In Appreciation of the Publication of *The Shadow of James Joyce*

I am pleased with the long-awaited publication of *The Shadow of James Joyce* by Motoko Fujita, consisting of a selection of her photographs complemented by learned essays specially for this project. Ms Fujita is originally a graduate from Baiko Gakuin University. She continues today to help promote the exchange programme between the university and St Patrick's College in Dublin. While at college, she recalls being awakened to her chosen vocation in response to a lecture given by an excellent man of letters invited to the university. After this realization, she completed her original degree.

In taking each photograph, not only does Ms Fujita afford full play to her ability to adjust the camera lens to achieve the sharpest possible image, but also she seeks to uncover and disclose the essential core of her subject. This dedication can be compared to the honest attitude toward art typified by Cézanne. He is said to have made a picture of nature by 'putting his soul into her bosom' and thus learning from her. I sincerely hope that Ms Fujita will continue her endeavor to fulfill this requirement for an artist. Indeed, this was a topic of conversation I once shared with her whilst we looked at the works produced by the photographer Mario Giacomelli. Only then did she go to Ireland in pursuit of her vocation.

This book has been completed through just such a process of artistic honesty. It retraces, on the basis of footprints left by the writer James Joyce, an impressionistic history of Ireland in miniature, focusing on a single village lying at the outskirts of the capital, Dublin. All of the featured photographs taken by Ms Fujita are monochrome and vividly reflect the unique culture and history of Ireland, a culture and a history not wholly subsumed by European civilization. A monochrome photograph is a physical thing capable of making the original and deep shades of the existence of a human being and of nature shine forth: it is potentially epiphanic. At the same time, it is able to reveal the passion and thinking in the photographer's mind.

One is immediately struck by the photographer's recognition of the deeply traditional signatures visible even today in the Irish landscape, interpreted through a sensitivity Japanese in nature. This fusion of cultures is facilitated, perhaps, by the geographical similarities between Japan and Ireland, small islands sited historically in the great shadow.

I have decorated my office with a photograph by Ms Fujita of an aged maple tree in what remains of an old Japanese garden in Chapelizod. This picture gives me peace of mind.

I know but little about photography and Irish culture; however, this excellent collection of photographs and essays has a great and unique attraction for me. I offer Ms Fujita my congratulations on her achievement. Moreover, I wish from the bottom of my heart that this work will catch many people's eye, and that she and her fine work will attain ever more growth and maturity.

<div align="right">Guest Professor of Baiko Gakuin University, Yasumasa Satoh</div>

inspiration

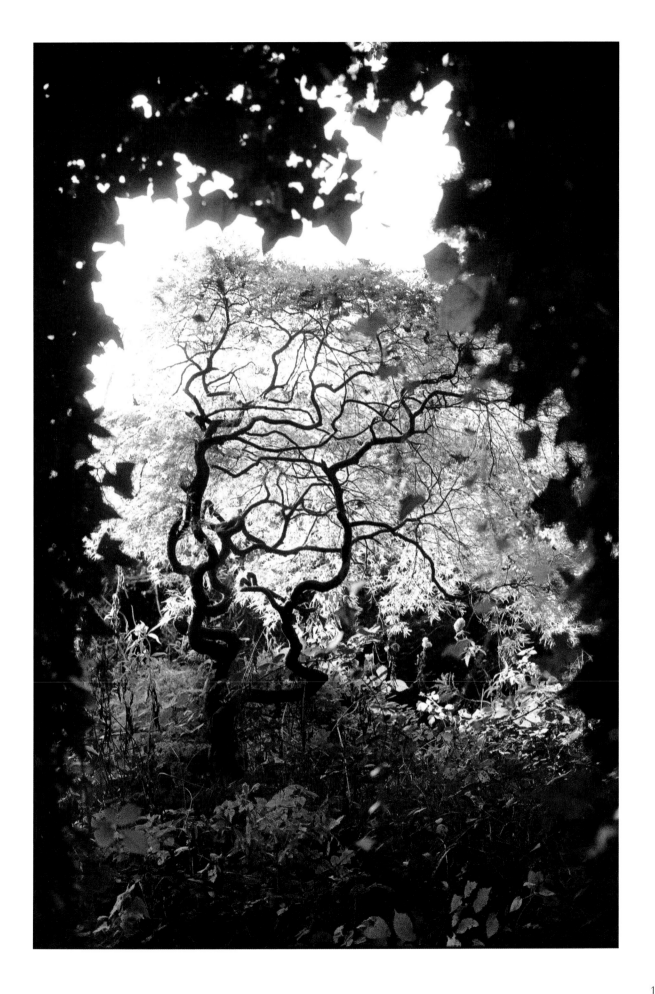

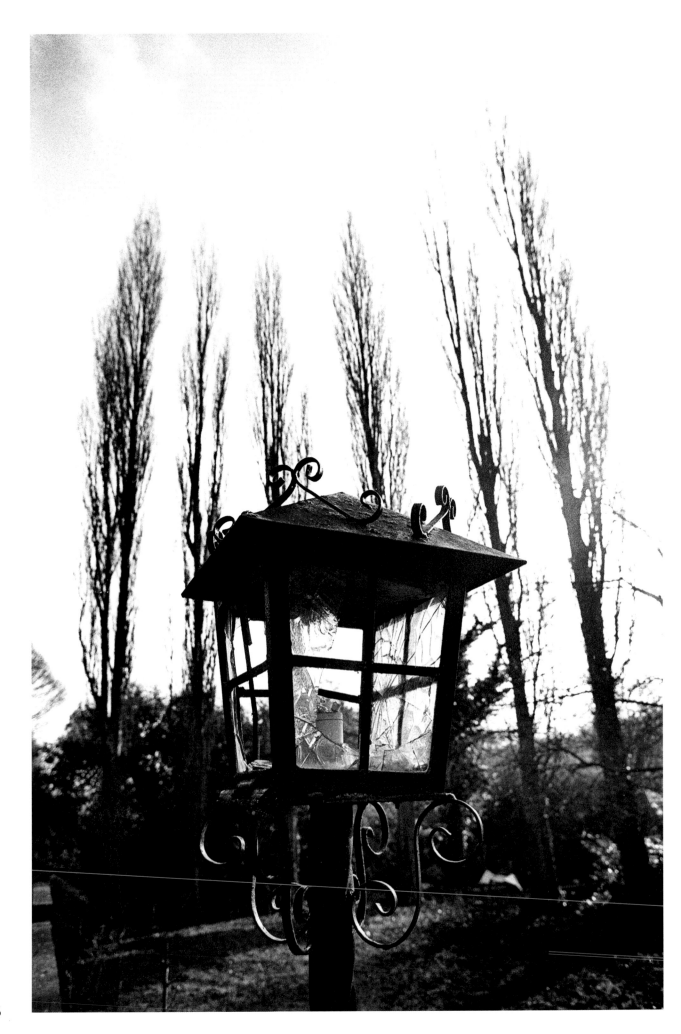

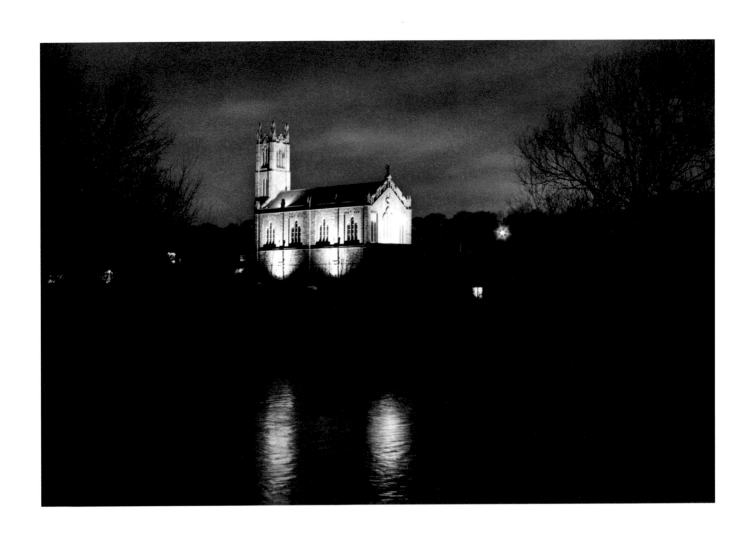

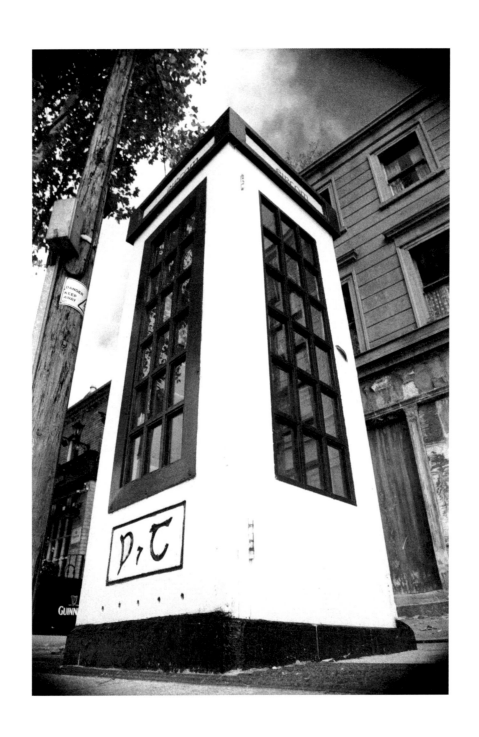

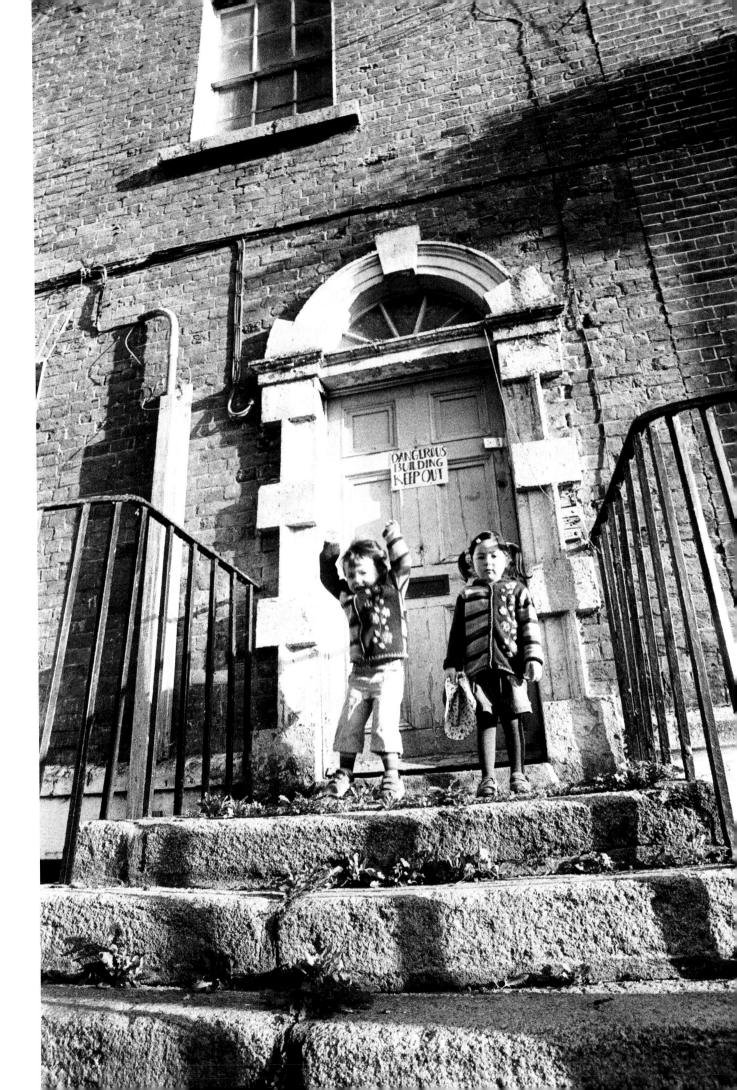

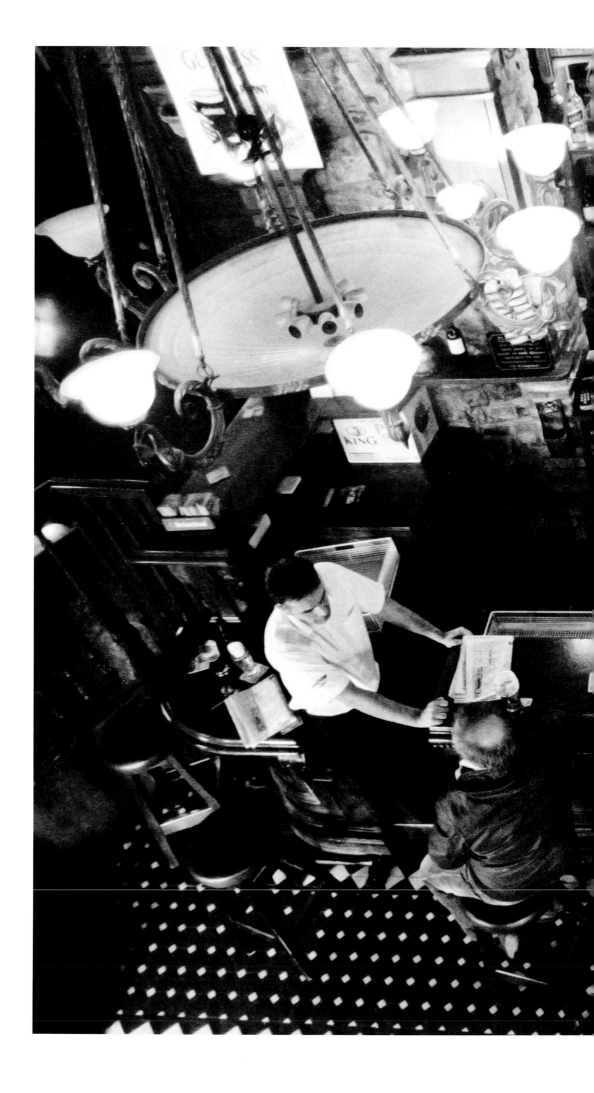

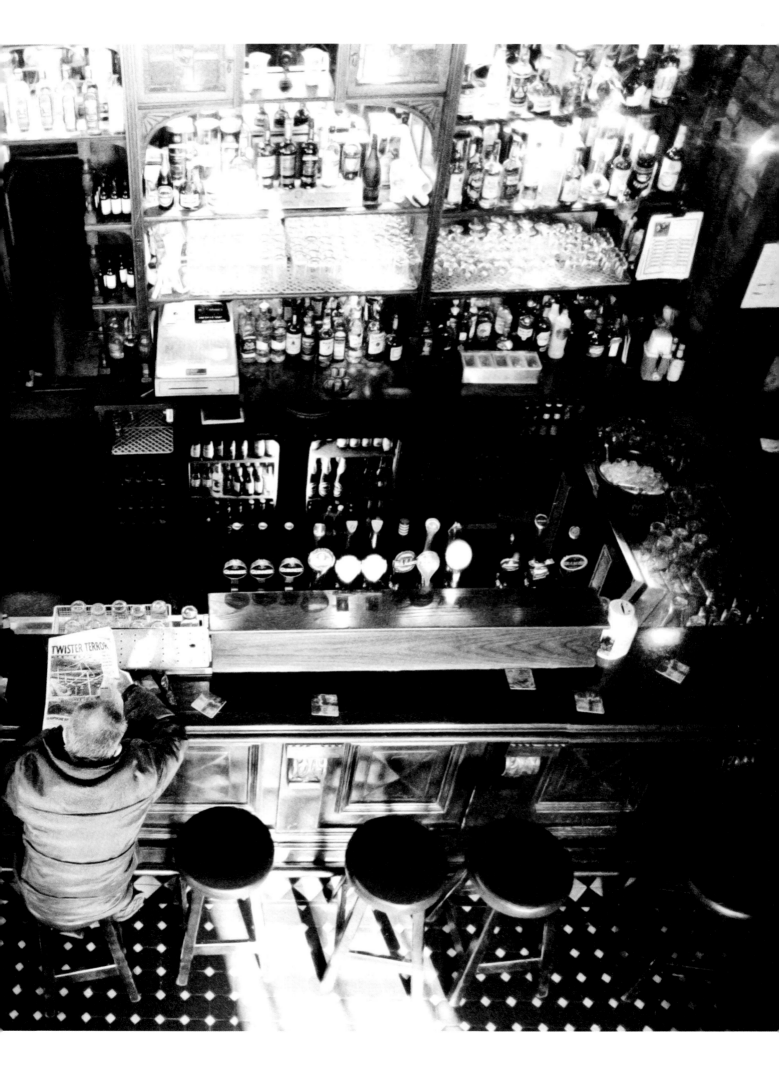

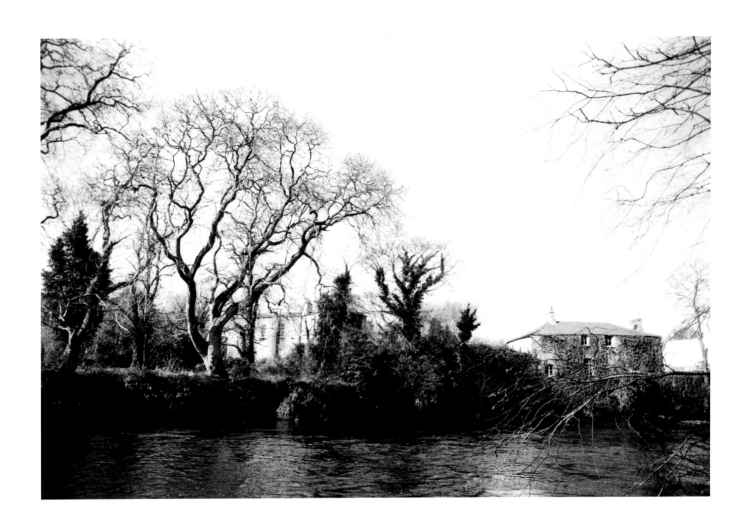

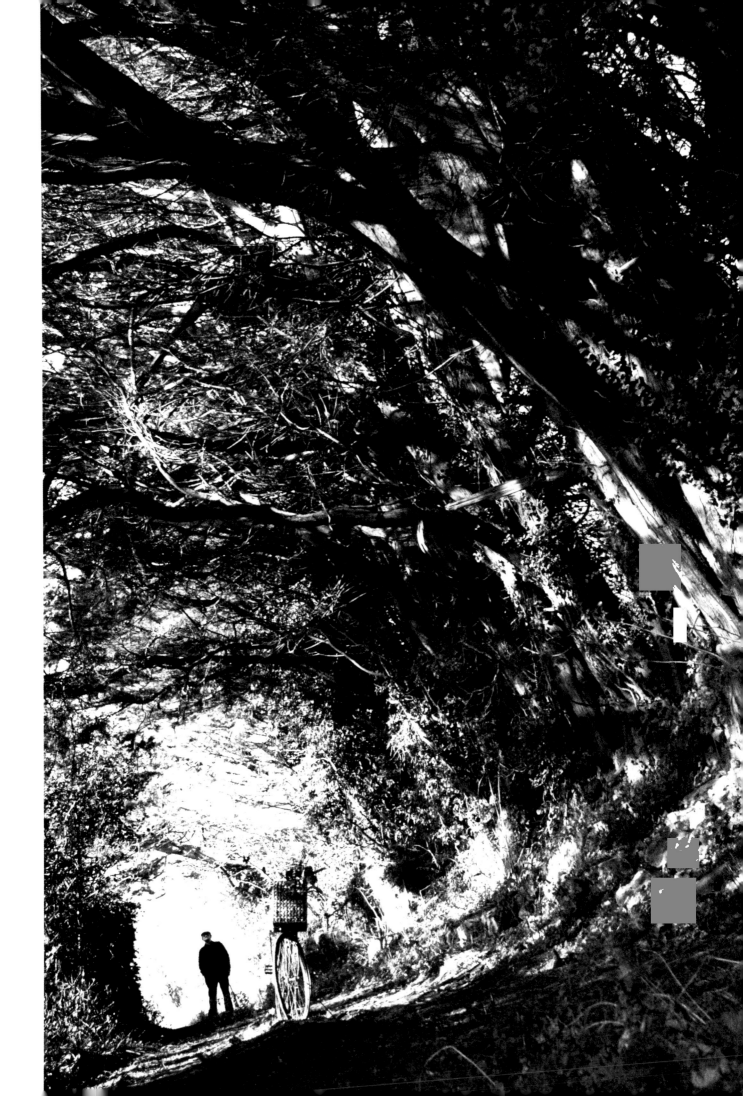

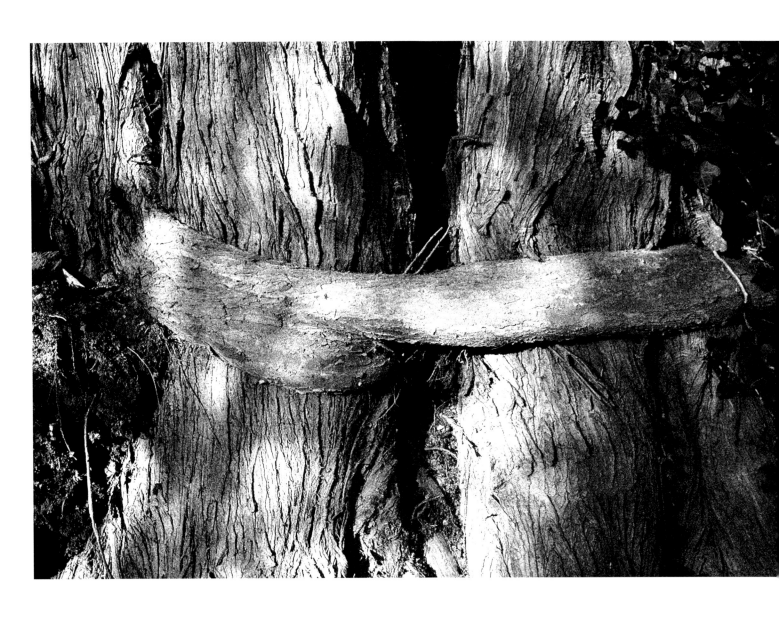

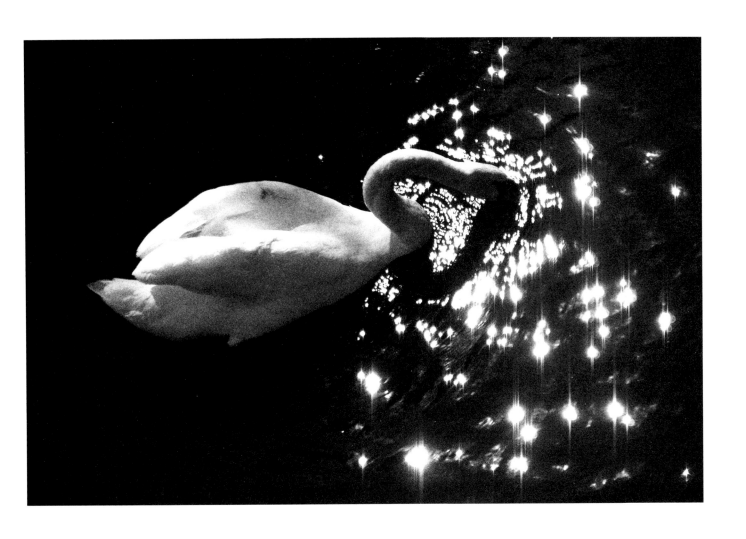

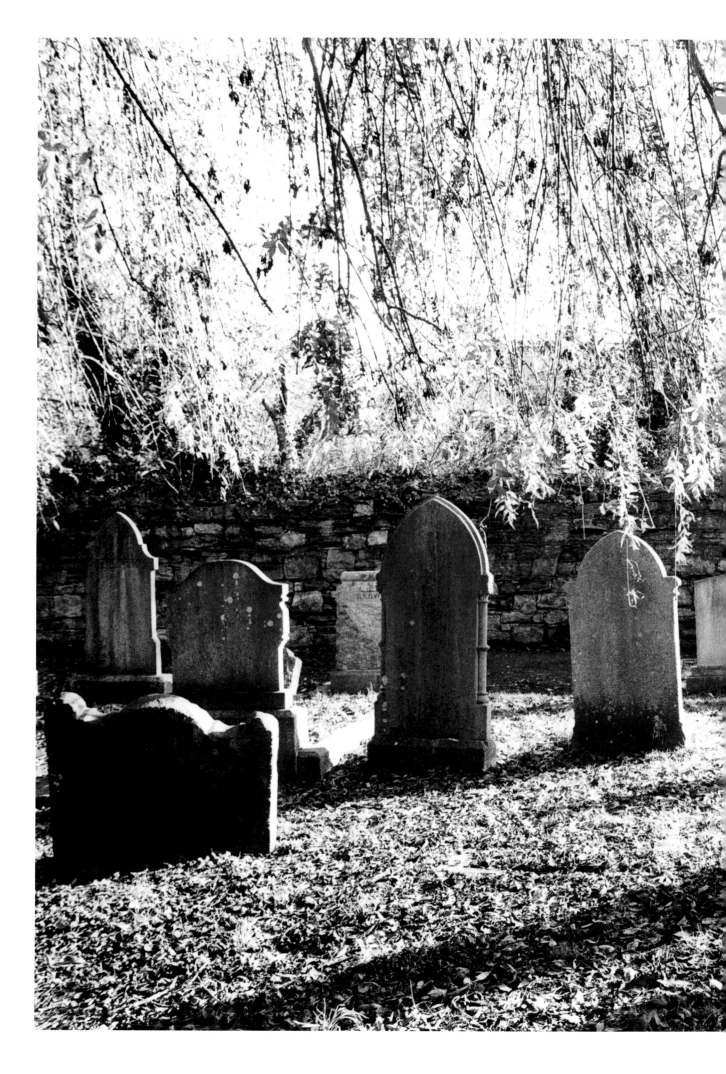

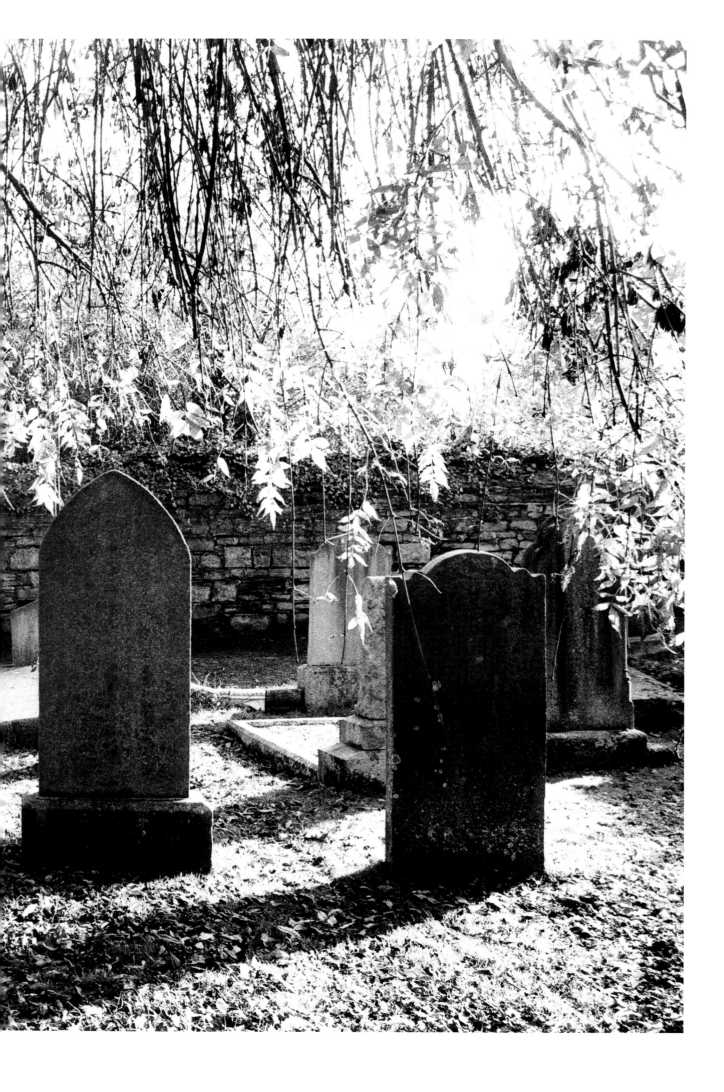

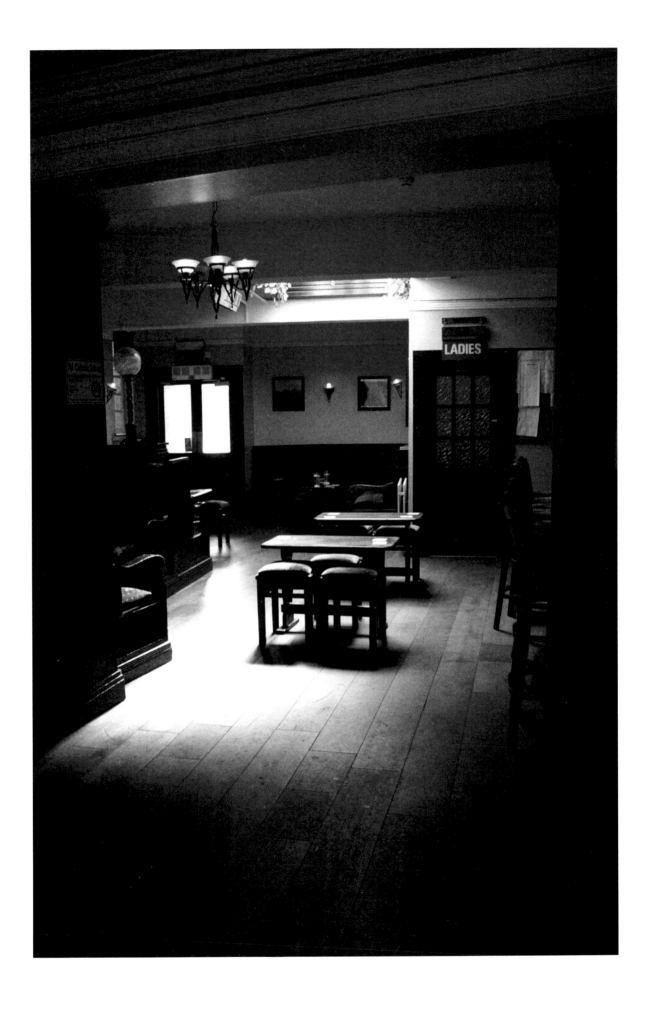

DAVID NORRIS

Of the nine Chapelizod-referenced images sent to me by the photographic artist Motoko Fujita to inspire a casual jotting about Joyce, the image that immediately attracted me was relatively straightforward and very atmospheric. It was of the interior of a Chapelizod pub, empty except for light shining from three sources – an assortment of electric lights, the vague penetration of daylight and a sign for the ladies' lavatory. They reveal by their shadowy reflection in the gloom a typical old-fashioned Dublin pub interior with some workaday public-house furniture standing on bare boards. There is no human figure present. Indeed the only living thing visible is a vague hint of green tendrils from plants apparently suspended from a skylight. The atmosphere is halfway between Joyce and Beckett.

I think Joyce would have liked the image and cherished its emptiness, having once asserted during his college days that absence was the highest form of presence. There is here something of the feeling contained in those Hockney paintings of a sunlit California room, clothes recently and casually discarded, and a gauze veil of curtain rippling in the wind. The onlooker experiences a poignant sense of the occupant having just left.

The very ordinariness would also have attracted Joyce, as he crafted his fiction out of the ordinary and the everyday. The extraordinary, he maintained, was for the journalist. His art divined meaning and universality in the humdrum. Like his alter-ego Stephen Dedalus in *A Portrait of the Artist*, he turned his back disdainfully upon the proffered priesthood of the Roman Catholic Church. Joyce, the priest of the eternal imagination, through his mastery of language sought to distil the humble elements of human life into the everlasting. He believed that he did so in a manner analogous to that in which the ordained priest, by the invocation of the Holy Spirit, transforms the simple elements of bread and wine into the body and blood of Christ during the Mass.

The author was well acquainted with Irish drinking habits. During his childhood, he was dragged around the pubs of both Dublin and Cork by his father in the early course of a downward spiral of drinking that finally landed the entire extensive Joyce household in the gutter. Despite the fact that in recent years the connection between Joyce and public-houses inspired an award in his name for the 'Best Dublin Pub', there are few genuinely Joycean pubs left in Dublin other than Mulligans of Poolbeg Street. In its own way, Davy Byrne's 'moral pub' in Duke Street also retains an honorable sense of (Ulyssean) apostolic succession and sponsors a literary prize in Joyce's name.

John Stanislaus Joyce had an even more intimate and encyclopedic knowledge of Dublin pubs. In his halcyon days, as he later recalled, he once snapped the necks of champagne bottles against the marble counter of a fashionable city-centre watering-hole in his eagerness to get at the contents without the bother of having to extract the cork. This bacchanalia formed part of the celebration of an election victory in which he played a significant role on behalf of the successful Parnellite candidate. But John Stanislaus soon thereafter found his appropriate level in the spit-and-sawdust of the lesser haunts that his son would immortalize in *Ulysses*.

Drink brought John Stanislaus to Chapelizod. Before he became merely a 'praiser of his own past', he had a job as secretary to a distillery in the area, in which he (unwisely) invested some of his own dwindling resources and which

characteristically went bust within a year of his tenure of office. Curiously for a man of his habits, he exposed the nest of fraud and embezzlement perpetrated by one of his fellow directors that finally brought the establishment down. He boasted to his son that the gratitude of the shareholders, expressed in financial form, nestled somewhere in a lost account in the Bank of Ireland. After his father's death, Joyce tried in vain to locate this small but tantalizingly evasive hoard. In the company of Joyce senior, the young James visited various places of refreshment around Chapelizod, and although *Finnegans Wake* takes place in a dream world, the location of that dream is appropriately a Chapelizod pub.

In the photograph the visual image evokes other senses. As you look you can almost smell the flabby gush of porter that flowed in 1904, not just from Larry O'Rourke's pub in Dorset Street but generally from pubs all over Dublin, as it also no doubt does, even now, from the original of the still life in the picture.

Senator and Joyce scholar

BARRY MCGOVERN

'Mr James Duffy lived in Chapelizod because he wished to live as far as possible from the city of which he was a citizen and because he found all the other suburbs of Dublin mean, modern and pretentious.'

So begins James Joyce's story 'A Painful Case'. This story, from the collection *Dubliners*, is set mainly in Chapelizod. In *Ulysses* Chapelizod is mentioned only once by name. But there are many references to areas around Chapelizod. The Phoenix Park is often mentioned in relation to the murders of Cavendish and Burke there in May 1882 and of course *Finnegans Wake* is inextricably linked with Chapelizod.

But to begin at the beginning. In *A Portrait of the Artist as a Young Man*, Stephen Dedalus, in reply to Cranly's question about Stephen's father 'What was he?' enumerated glibly his father's various occupations. Among a long list of activities is the phrase 'something in a distillery'. The distillery in question was the Dublin and Chapelizod Distillery Company of which John Joyce, Joyce's father, became secretary. It was later known as the Phoenix Park Distillery. Previously the property had housed a barracks and a flax mill.

In late 1872 or early 1873 John Joyce applied for the post of secretary of the distillery company, which was to be set up in Dublin by a man called Henry Alleyn together with another man, a Cork businessman. John Joyce also offered to take up shares in the distillery. The offer was accepted and he got the job.

The site of the distillery was formerly the barracks of the Irish Royal Artillery regiment and had been developed as a flax mill by William Dargan after the Great Dublin Exhibition of 1853. In *Finnegans Wake* it is referred to as 'the still that was mill'. Dargan's death led to the eventual demise of the mill and most of the machinery was sold off. On 23 June of that year Alleyn leased, for 900 years, the site of nearly ten acres when it was put on the market after the death of the man who had run the mill after Dargan. The mill had run on water power and the great wheels were still in place to be utilized for the distillery. Portions of them are still there. On 22 September 1874, the Dublin and Chapelizod Distillery Company was incorporated with offices at Dame Street. Some time later the company office was moved to Chapelizod. Production had begun in late 1873 and by early the following year the distillery was well under way. It was fully at work by November when the buildings were formally leased to the Dublin and Chapelizod Distillery.

By this time Chapelizod already had important literary associations. Joseph Sheridan Le Fanu lived there for over ten years as a child when his father was chaplain to the Royal Hibernian Military School in the Phoenix Park – now St Mary's Hospital. His novel of 1863, *The House by the Churchyard*, is set in Chapelizod and is full of the sort of characters he would have met during the formative years of his childhood. This novel looms large in *Finnegans Wake* and references to both it and some of its characters in Joyce's final magnum opus are legion. Le Fanu's novel was one of the few books John Joyce owned.

James Joyce himself got to know Chapelizod well from early childhood as the family often went for picnics to the Strawberry Beds. He would have learned at an early age about the legend of Tristan and Isolde, which features so prominently in *Finnegans Wake*. Indeed Chapelizod means the chapel of Iseult or Isolde, the Irish name being Séipéal Iosoid.

Joyce would also have picked up from his father some of the technical jargon used in the operation of a distillery. In 'The Sisters', the first story in *Dubliners*, Old Cotter is spoken of by the child narrator as a 'Tiresome old fool! When he knew him first he used to be rather interesting, talking of faints and worms, but I soon grew tired of him and his endless stories about the distillery.'

John Joyce has left reminiscences about the various inns or bars in Chapelizod. In reply to his son's enquiries about the Broadbent family who ran the Mullingar Inn – a central focus in *Finnegans Wake* – John Joyce spoke fondly of his time in Chapelizod. Despite this, things did not go well at the distillery and it was wound up in 1878. Henry Alleyn, in James Joyce's eyes, was someone who enriched himself by shady means and Joyce later got revenge on his father's behalf by giving the obnoxious solicitor in the story 'Counterparts' the name Alleyne.

But it is the story 'A Painful Case' that is most firmly associated with Chapelizod. In this story Mr James Duffy, an emotionally dysfunctional man, travels each day by tram from Chapelizod to his work in a bank in Baggot Street. One evening at a concert in the Rotunda he strikes up an acquaintance with a lonely woman whose husband was nearly always away. After encountering her accidentally on two further occasions they arrange to meet. Not wishing to engage in any subterfuge, Mr Duffy ensures that she asks him to her house. The woman's husband, a ship's captain, encourages Mr Duffy's visits, thinking he was interested in his daughter who was with his wife when the first encounter took place. They meet up many times after that and he shares his intellectual life with her. When she begins to make known the physical attraction he has for her, he cuts off all relations with her.

One day, four years later, as he is dining as usual in Georges Street he is shocked to read something in his evening paper. He pays his bill and walks the few miles back to Chapelizod. He goes up to his bedroom and rereads the article: 'DEATH OF A LADY AT SYDNEY PARADE – A Painful Case.' It is a report of an inquest on the lady, Emily Sinico, who had been killed by a train that was pulling out from Sydney Parade railway station on its way towards Dublin. The implication of the report is death by suicide. Mr Duffy is both shocked and disgusted: 'What an end! The whole narrative of her death revolted him and it revolted him to think that he had ever spoken to her of what he held sacred.' He regards her action as not only having disgraced herself but having degraded him too. He muses that 'she had been unfit to live, without any strength of purpose, an easy prey to habit, one of the wrecks on which civilization has been reared. But that she could have sunk so low!' He realizes now how right had been the course he had taken.

He goes into a local pub and over a couple of hot punches broods over their relationship and what had happened. He convinces himself that he is in no way to blame.

He leaves the pub and walks through the Phoenix Park to Thomas's Hill and the Magazine Fort. Now his guilt rises and he asks himself why he behaved as he did. He seems to feel her voice in his ear, her hand touching his. He asks himself why he had sentenced her to death. 'He felt his moral nature falling to pieces.' He sees lovers lying together in the shadows and twice we read the phrase 'outcast from life's feast', referring to himself. He sees a goods train winding out of Kingsbridge Station 'like a worm with a fiery head winding through the darkness' and hears the drone of the engine reiterating the syllables of her name: Emily Sinico, Emily Sinico.

Under a tree he halts, doubting the reality of what memory told him. 'He waited for some minutes listening. He could hear nothing: the night was perfectly silent. He listened again: perfectly silent. He felt that he was alone.'

This story, written when Joyce was only twenty-three, was one of Joyce's least favourite. He never seems to have been satisfied with it. It was written in Trieste in July 1905 just before the birth of his first child Giorgio. The idea for the story came from entries in his brother Stanislaus's diary. In 1901 Stanislaus, aged only sixteen or seventeen, had attended a concert in the Rotunda given by the contralto Clara Butt. He noticed a woman who was between thirty and forty sitting beside him, who looked at him several times. They spoke and later met in the street when they spoke again. They never met after that. Joyce gave Mr Duffy some of Stanislaus's characteristics and also some of the sentences he used to jot down in a notebook, such as: 'Every bond is a bond to sorrow' and 'Love between man and man is impossible because there must not be sexual intercourse, and friendship between a man and a woman is impossible because there must be sexual intercourse.'

Joyce here, as in all his work, makes art out of his own life experiences. The insight into human nature that the young Joyce shows in this story is wondrous: way beyond his years. It is, to my mind, one of the best stories in *Dubliners*.

One last point. There has been some discussion as to the location of Mr Duffy's house, the pub he visits and the gate by which he enters the Phoenix Park. There are arguments for the Lucan road, the Bridge Inn and the Park Lane

pedestrian gate. But I'm more inclined to think that the house is Le Fanu's *The House by the Churchyard*. 'He lived in an old sombre house and from his window he would look into the disused distillery or upwards along the shallow river on which Dublin is built'; and 'the river lay quiet beside the empty distillery and from time to time a light appeared in some house on the Lucan road'. The Le Fanu house, or one like it, fits the bill perfectly with regard to these descriptions. If this is the house then the pub must be the Mullingar Inn or Mullingar House as it's now known. 'When he came to the public-house at Chapelizod Bridge he went in and ordered a hot punch.' The Bridge Inn is obviously at the bridge but the Mullingar House, being at the end of the stretch of road most of which includes the bridge, is arguably 'at Chapelizod Bridge'. And if this is so (or, indeed, if the pub were the Bridge Inn), the gate by which Mr Duffy entered the Phoenix Park must be the Chapelizod Gate. If he had been in either of the pubs mentioned, he would have had to retrace his steps to go in by the Park Lane Gate. But whatever the commentators like to think, we must remember that the story is fiction and the ambiguity of the details is part and parcel of the writing.

'A Painful Case' is a masterful achievement in the short-story form. The setting of Mr Duffy's house in Chapelizod owes much to James Joyce's experiences with his family in that area, his reading of Sheridan Le Fanu and the happy chance of his father having worked for some time there over one hundred and thirty years ago.

Actor

A WAKE IN CHAPELIZOD

SAM SLOTE

Inverting a formula popular in these ecologically sensitive times, in *Finnegans Wake* Joyce thinks locally yet acts globally. That is, Joyce filters something like an amalgamation of all world histories, languages, cultures, arts, sciences, religions, myths, and so forth through a distinctly local, Irish prism. Through Ireland Joyce, somehow, represents the whole world, but in so doing he retains the specificity of his Irish home – a home he had last visited a decade before he began writing *Finnegans Wake* in 1922. When Joyce refers to 'Howth Castle and Environs' (FW: 3.03), the environs are as global as they are Hibernian, as if the whole world were a suburb of Dublin.

As he was beginning conceptualizing and writing what would become *Finnegans Wake*, Joyce was exceptionally interested in exploring the resonances of the legend of Tristan and Isolde. Back in 1918 he had told his friend Georges Borach, 'There are indeed hardly more than a dozen original themes in world literature. Then there is an enormous number of combinations of these themes. Tristan und Isolde is an example of an original theme.' Beyond its originality, there are numerous reasons why this tale would interest Joyce: it is an Irish story, but with resonances throughout many other countries, and it is a story that exists in numerous different variations across the ages, from Arthurian legend to Wagner, with no one single definitive version – although in 1900 the French philologist Joseph Bédier attempted to reconstruct an ur-version. In 1907, while he was living in Trieste, Joyce delivered a lecture entitled 'Ireland: Island of Saints and Sages' in which he argued that all races and cultures, especially the Irish, are mixed: 'What race or language can nowadays claim to be pure? No race has less right to make such a boast than the one presently inhabiting Ireland.' With its mixed pedigree and its confused genealogy, the legend of Tristan and Isolde is thus a perfect expression of the mixed nature of Ireland and the Irish.

While Joyce's interest in using the legend of Tristan and Isolde for his new book evolved into a different set of configurations, some of the basic patterns of the story remain in the *Wake* with the patriarchal character Humphrey Chimpden Earwicker having developed from King Mark, his sons Shem and Shaun from Tristan, and, unsurprisingly, the two Issys from Isolde or Iseult (who is herself split in the pair Isolde of Brittany and Isolde of the White Hands). In turn, Joyce's interest in the legend of Tristan and Isolde led him to Chapelizod, Isolde's chapel, where she is reputed to have lived and is perhaps the oldest village in the Dublin environs, the ur-Dublin as it were.

Of course, the story of Tristan and Isolde is not the only literary references relevant to Chapelizod. Sheridan Le Fanu set his gothic mystery novel *The House by the Churchyard* in Chapelizod and so Joyce makes numerous references to 'the old house by the churplelizod' (FW: 96.07), or, as it is in a slightly Dutch vein, 'De oud huis bij de kerkegaard', which also includes a reference to the Danish philosopher Søren Kierkegaard.

At one point in 1930 Joyce considered naming chapter II.1 of the *Wake*, the chapter of children's games, 'Chapelle D'Izzied'; however, he eventually settled on the title 'The Mime of Mick, Nick, and the Maggies'. Within that chapter there is a most interesting reference to Chapelizod. Six times in the *Wake* Joyce cites, with varying degrees of Wakean distortion, a sentence that Joyce called 'beautiful', which comes from the book *L'Introduction à la philosophie de l'historie de*

la humanité by the French philosopher of history, Edgar Quinet. Quinet writes of the effects of historical change and so the variations that Joyce inflicts on his sentence are exemplary of the very processes of history that Quinet is describing. In chapter II.1 of the *Wake* we read:

> Since the days of Roamaloose and Rehmoose the pavanos have been strident through their struts of Chapelldiseut, the vaulsies have meed and youdled through the purly ooze of Ballybough, many a mismy cloudy has tripped taintily along that hercourt strayed reelway and the rigadoons have held ragtimed revels on the platauplain of Grangegorman; and, though since then sterlings and guineas have been replaced by brooks and lions and some progress has been made on stilts and the races have come and gone and Thyme, that chef of seasoners, has made his usual astewte use of endadjustables and whatnot willbe isnor was, those danceadeils and cancanzanies have come stimmering down for our begayment through the bedeafdom of po's taeorns, the obcecity of pa's teapucs, as lithe and limbfree limber as when momie mummed at ma (*FW*: 236.19–32).

As with Joyce's other versions of the Quinet sentence, the temporal marker at the beginning is altered: instead of Quinet's Pliny and Columella, Joyce has Romulus and Remus; so, instead of ancient historians, Joyce has mythological founders. Furthermore, Quinet's flowers have become dances (pavan, valses and rigadoons), an appropriate metamorphosis for this chapter in which the Maggies dance around Shem as he attempts to guess their colour. The point here seems to be that the dance endures through decay and entropy, much as children's games have lasted throughout history. Children's games are, on the one hand, fleeting: by definition one (usually) grows out of them. On the other hand, they have persist; individual players may grow up, but they will always be replaced by subsequent generations, thereby allowing for the continuation of the games. Furthermore, in this particular variation on Quinet's theme, Joyce substitutes Chapelldiseut for Quinet's 'les Gaules', thereby returning, in this game, Isolde back to Ireland from France. In so doing, he places Chapelizod at the centre of the myth of historical continuity and change. With the Phoenix Park, 'the most extensive public park in the world' (*FW*: 140.12–13), Chapelizod takes on the status of a kind of pastoral Hibernian Eden in *Finnegans Wake*, but it is an Eden that has not been abandoned, an Eden that has also grown and evolved.

Chapelizod's mixed municipal status, partly in Palmerstown parish and partly in Chapelizod parish, provides a neat suggestion of hybridity, which is, of course, a major theme within Joyce's book. In one of the earliest notebooks he compiled for *Finnegans Wake* Joyce wrote: 'Chapelizod in what constituency local Govt.' Under multiple jurisdictions, Chapelizod reflects the multiplicities of the world that form Joyce's subject, multiplicities with a Dublin accent. Always eager to further add confusion to hybridity, Joyce frequently conflates Chapelizod with the town of Lucan, which is farther to the west, in neologisms such as 'Lucalizod' (*FW*: 32.16) and 'unlucalised' (*FW*: 87.18). Even as Joyce universalizes the local – thereby, if you will, 'un-localizing' it – it retains its local colours.

Much of the apparent action, if such is the right word, of the *Wake* seems to involve an indiscretion that HCE may or may not have committed; his original sin or 'felicitous culpability' (*FW*: 263.31), as it were (or not). Within the book, there are so many different accounts of this indiscretion – through gossip, song, folktale, rumour, and so on – that it's impossible to state what, if anything, happened. As with the legend of Tristan and Isolde, the story exists across repetitions and variations, leaving the supposed original scene unknown and unknowable. The accusations begin in the book's second chapter initially as a means of attempting to disprove certain rumours that are circulating about HCE, or Humphrey Chimpden Earwicker, who is, we are told, 'magnificently well worthy of any and all such universalisation' (*FW*: 32.19–20). One such rumour is that 'he lay at one time under the ludicrous imputation of annoying Welsh fusiliers in the people's park' (*FW*: 33.24–26). He is here accused not so much of annoying these fusiliers as he is being accused of having been accused ('under the ludicrous imputation') of annoying said fusiliers. The location of this scene is the people's park, a reference to both the People's Park in Dún Laoghaire as well as to the People's Flower Garden in the Phoenix Park by Chapelizod. Like HCE, Dublin topography is mixed and universalized, in this case in the universalizable terrain known as the 'people's park', a suitable place for the character HCE, whose initials also stand for 'Here Comes Everybody' (*FW*: 32.18–19).

Even as references to HCE's ambiguous indiscretion proliferate, we can find further allusions to the Phoenix Park. For example, more ominously, he stands further accused of 'having behaved with ongentilmensky immodus opposite a pair of dainty maidservants in the swoolth of the rushy hollow' (*FW*: 34.18–20) – a reference to the Hollow, which is opposite to the main entrance to the zoo.

In many ways the Phoenix Park meshes perfectly well with Joyce's project of recording (and further complicating) the confusions of history and how gossip, rumour, and misapprehension have historical force. For example, the very name 'Phoenix Park' comes from a misunderstanding by English speakers of its Irish name, *Fhionn-Uisce*, which means clear water, after a spring in the park. The mistaken transliteration 'Feenisk' was subsequently corrupted to 'Phoenix' and this mistake is now enshrined in the name of the park as well as in a statue of the stately, mythological bird atop the Phoenix Pillar, which now stands in the centre of the park. As Joyce has it in *Finnegans Wake*, the genealogy of the park's nomenclature 'change… a well of Artesia into a bird of Arabia' (*FW*: 135.14–15).

The most famous event to have transpired in the park is also the subject of confusion and error. On 6 May 1882, the year of Joyce's birth, near the Viceregal Lodge in the Phoenix Park, a group of dissident Fenians calling themselves the Invincibles, who were committed to violence against the English regime, murdered Lord Frederick Cavendish, the new Chief Secretary of Ireland, and Thomas Henry Burke, Under-Secretary of Ireland. Burke was the Invincibles' chief target because he was an Irish Catholic, and thus considered a traitor. Burke also had designed some of the colonial government's more repressive policies designed to stifle opposition to British rule. Although the perpetrators were eventually brought to trial, much uncertainty remains as to what exactly happened on that night. Tom Corfe, in his 1968 book on the murders, writes, 'It is evidence riddled with doubt and untruth, vagueness and confusion, evidence which permits of no definitive account and which leaves much still hidden in mystery.' English outrage at the violence of the crime set back the cause of Irish independence for many years. And so, the murders were one of the 'original sins' of the long project of Irish nationalism.

The murders are alluded to a number of times in *Ulysses*. Twice the date is incorrectly given as 1881 (*U*: 7.632 and 16.608), thereby suggesting the confusion that surrounds the details of the murders and also, perhaps, a sign of Joyce's superstition in avoiding associating this event with the year of his birth. And so in the *Wake*, the 'fenian's bark' (*FW*: 580.28) is associated with the 'Fiendish park' (*FW*: 196.11), a park, that like Finn, rises again reborn, from a body of water (Fhionn-Uisce) into a magical bird: 'Phall if you but will, rise you must: and none so soon either shall the pharce for the nunce come to a setdown secular phoenish' (*FW*: 4.15–17).

Another important location within the Phoenix Park from which Joyce extrapolates a the conflicts of historical retellings is the Wellington Monument; and in this case the conflicts of historical retellings directly involve conflicts. Much like most of the monumental architecture strewn around Dublin, this obelisk has acquired the sardonic nickname of the 'overgrown milestone', a name that Joyce changes to an 'overgrown babeling' (*FW*: 6.31), suggesting that the events it commemorates are confused, much like the confusion of languages after the destruction of the Tower of Babel. And so, within the *Wake*, Joyce babelizes the structure that commemorates Wellington as the 'big Willingdone mormorial' (*FW*: 008.34–35); *mormor* is Greek for the bogeyman since, indeed, any monumental edifice is designed to inspire both shock and awe. Wellington is said to have remarked, when asked if he was Irish, 'If a gentleman happens to be born in a stable, it does not follow that he should be called a horse.' In Joyce's 'museyroom' he is thus called a 'bornstable ghentleman' (*FW*: 10.17–18). And so, in the *Wake*, Joyce deconstructs the 'monomyth' (*FW*: 581.24) of an imperious and triumphant Wellington.

Finally, the hapless Earwicker of *Finnegans Wake* apparently is the humble landlord of the tavern called the Mullingar House, or the 'Mullingcan Inn' (*FW*: 64.09), which rose from the ashes, as it were, on the site of the old Phoenix House in Chapelizod, which appears in Le Fanu's *The House by the Churchyard* as 'the jolly old inn just beyond the turnpike at the sweep of the road, leading over the buttressed bridge by the mill first to welcome the excursionist from Dublin.' And, as Joyce has it, 'When you're coaching through Lucalised, on the sulphur spa to visit, it's safer to hit than miss it, stop at his inn!' (*FW*: 565.33–34).

In many ways, the use and abuse Joyce inflicts on Chapelizod is a microcosm of his treatment of history and language in *Finnegans Wake*: as something eminently, universally fungible, yet, somehow, ineluctably Irish. He makes the local universal while it still retains the traces and character of its locality, its Lucalizod, as it were.

Joyce Scholar

instauration

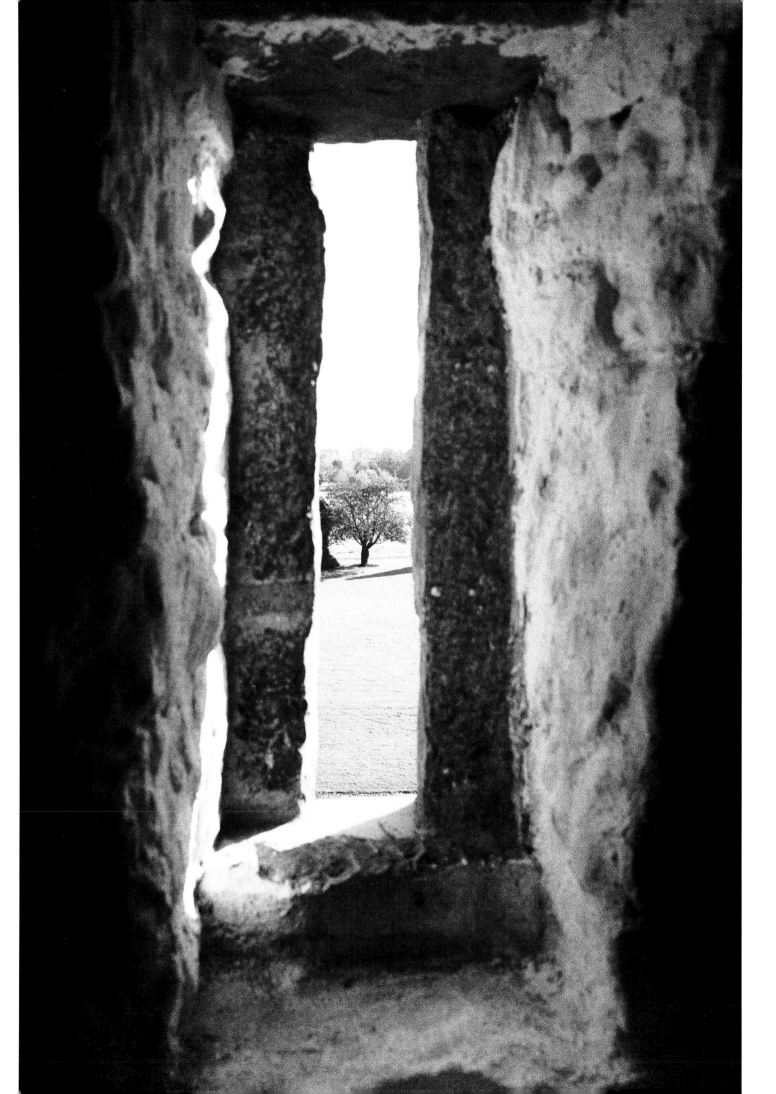

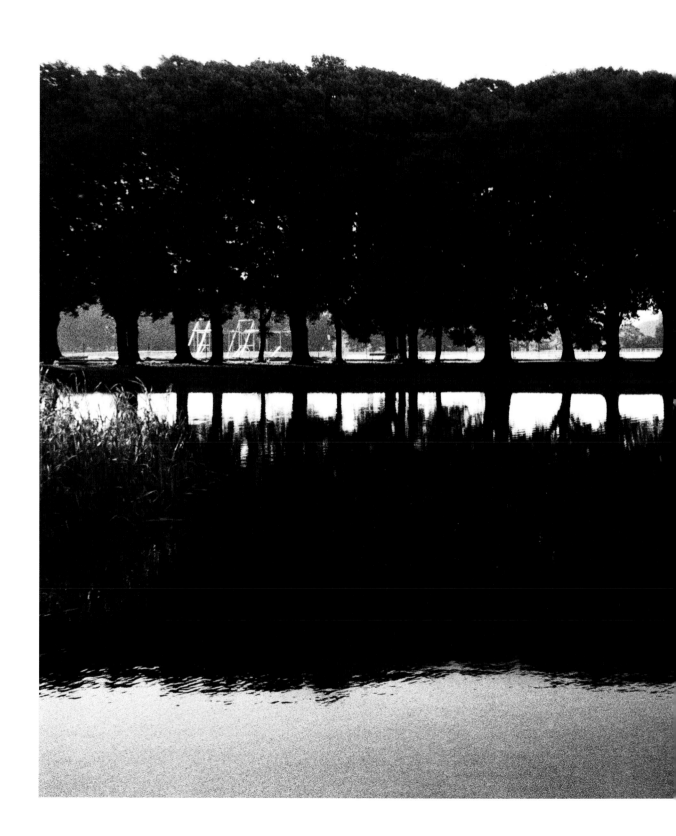

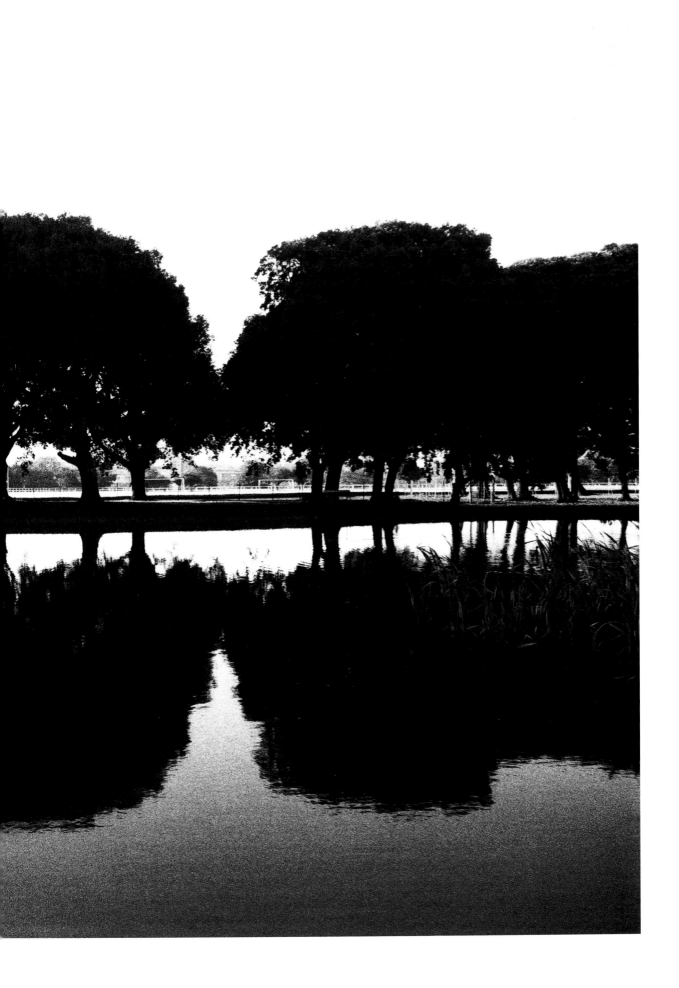

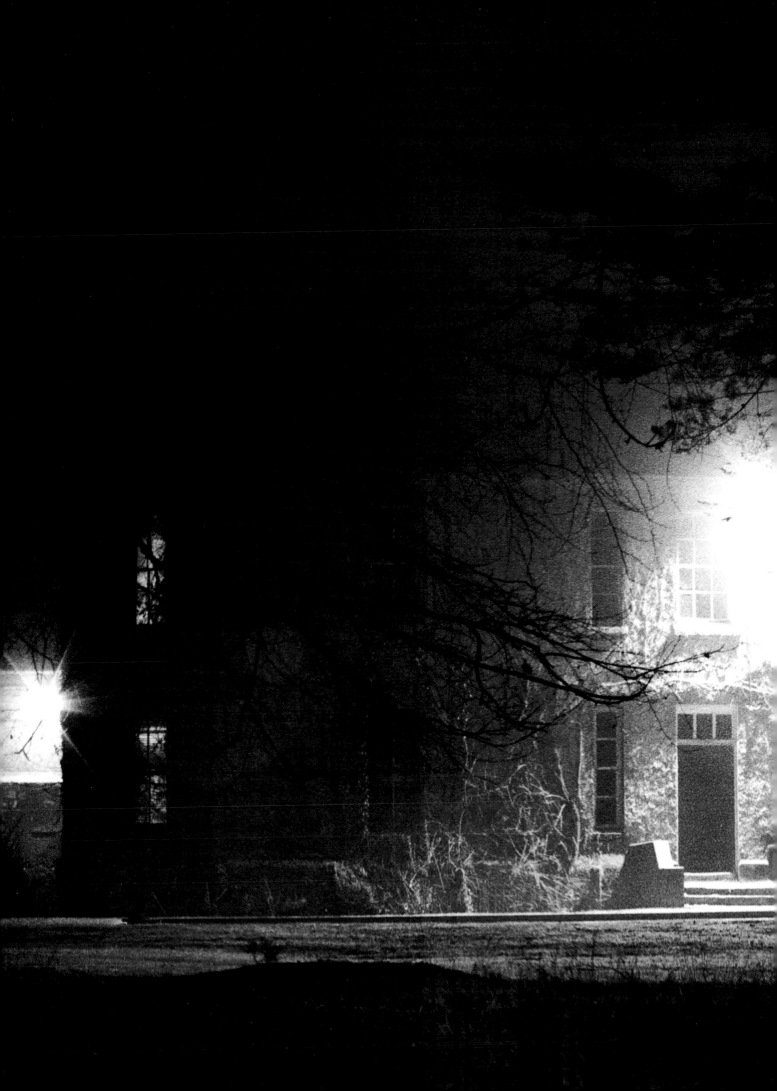

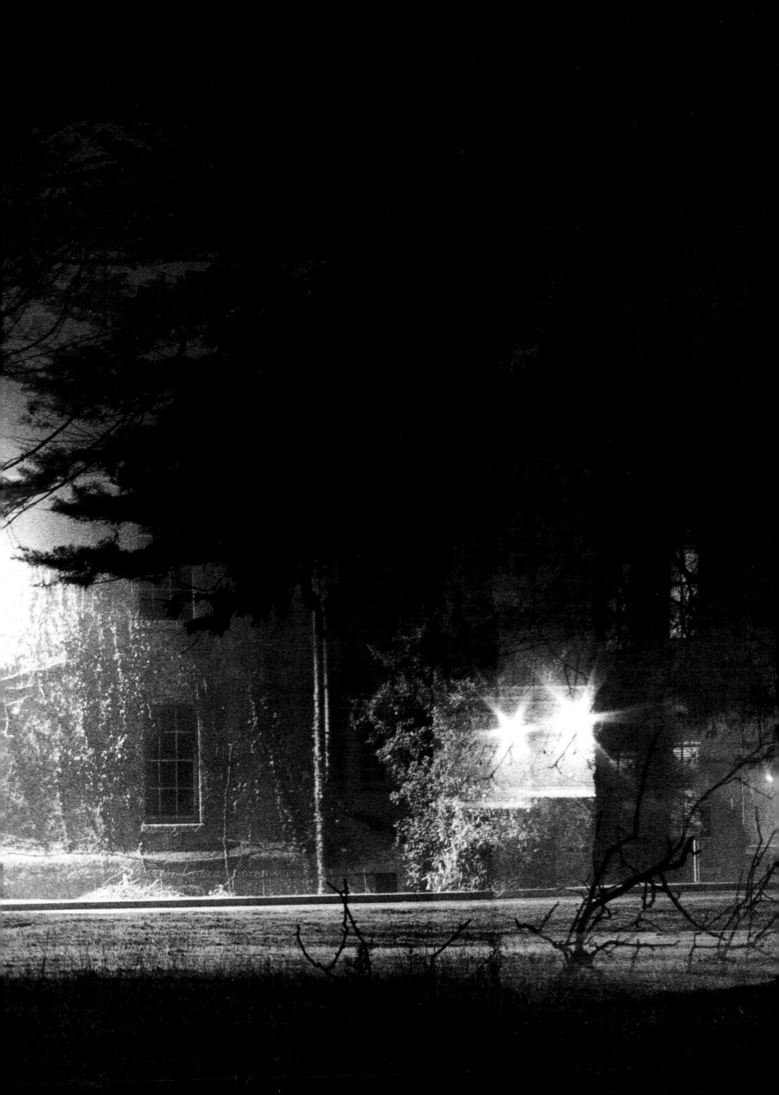

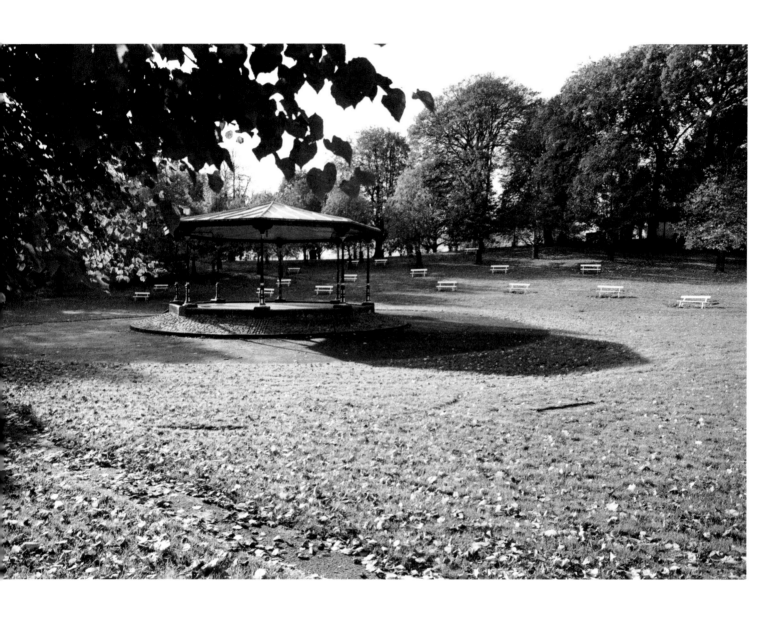

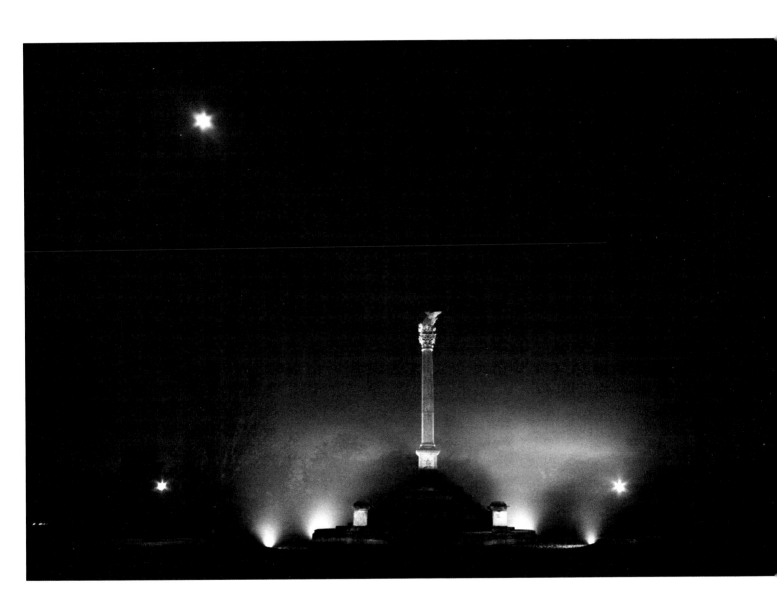

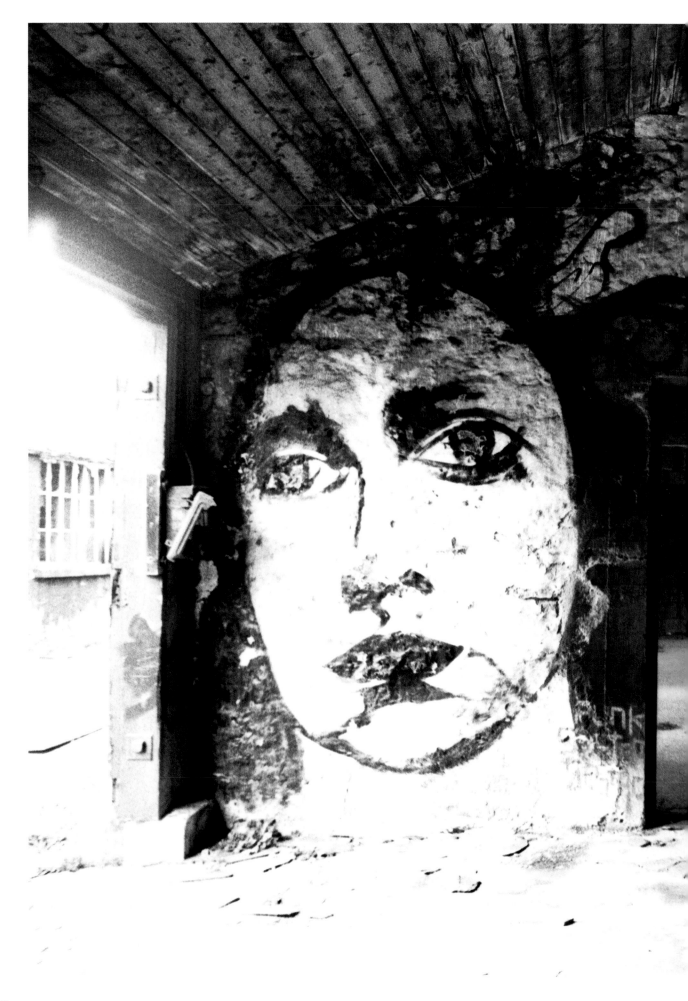

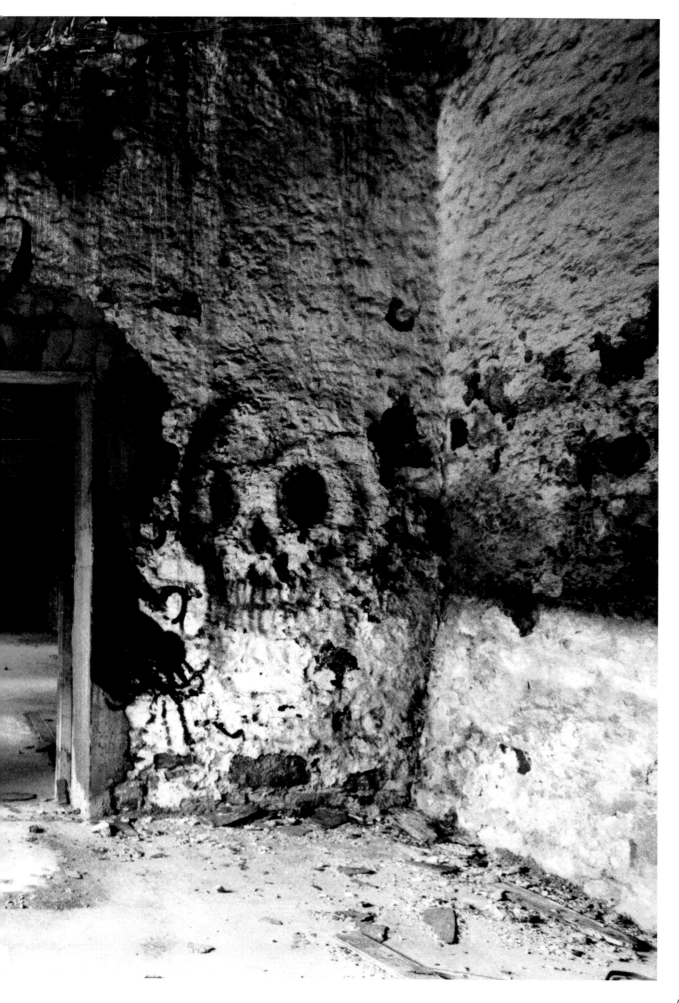

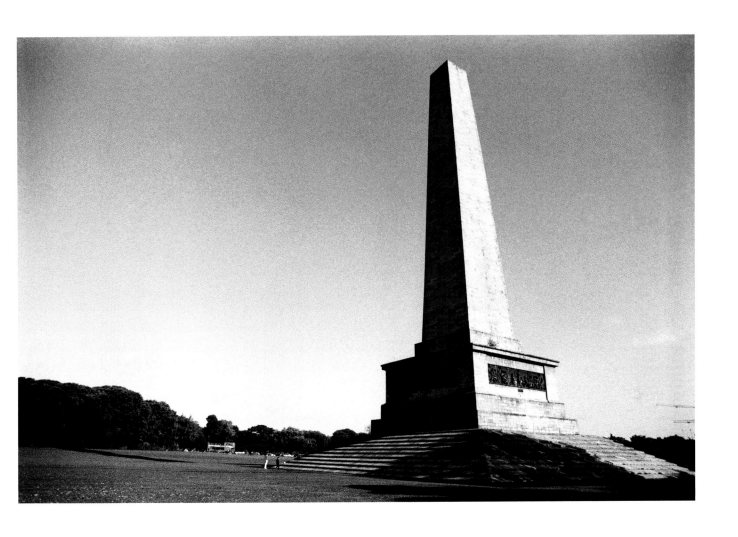

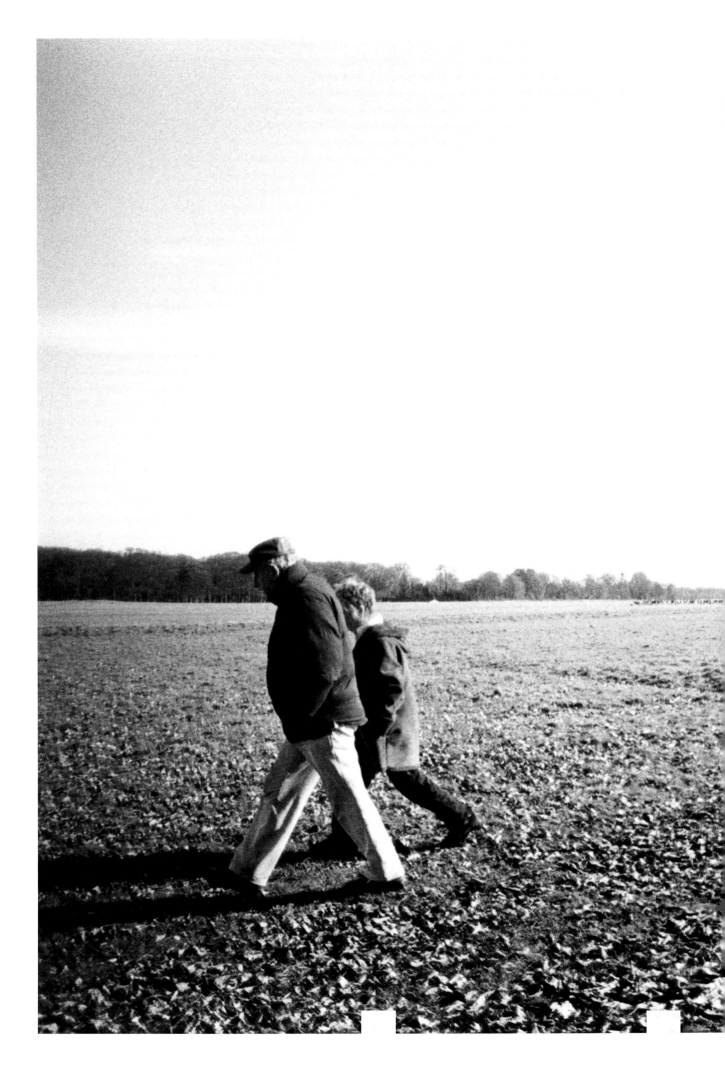

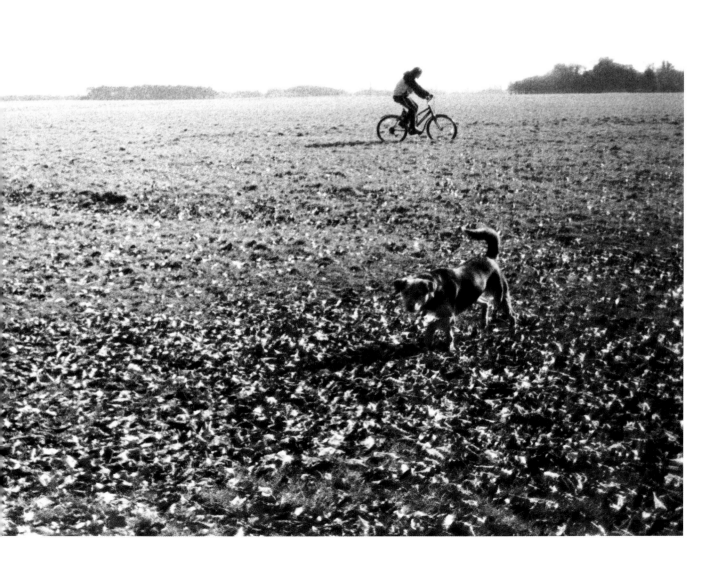

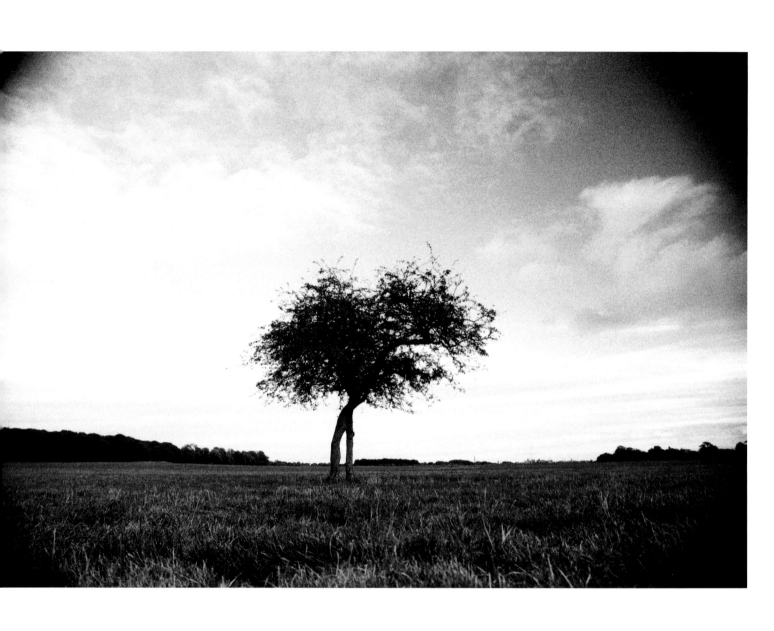

CHAPELIZOD – THE SHADOW OF JAMES JOYCE IN PHOENIX PARK

JOHN A. McCULLEN

THE FORMATION OF THE PARK

The Phoenix Park was established from 1662 onwards by one of Ireland's most illustrious viceroys, James Butler, Duke of Ormond, on behalf of Charles II. Conceived as a royal deer park, it initially included the original demesne of Kilmainham Priory south of the River Liffey, but with the building of the Royal Hospital at Kilmainham, which commenced in 1680, the park was reduced to its present size, all of which is now north of the river. Shortly after the Park's acquisition it was enclosed with a stone wall, which was initially poorly constructed. Subsequent wall repair and new buildings were necessary as the Park's size and boundaries were adjusted and realigned. In 1668, Marcus Trevor, Viscount Dungannon, was appointed Ranger, who with two other keepers were responsible for the deer, managing the Park's enclosures and newly formed plantations.

THE EIGHTEENTH CENTURY AND THE CHESTERFIELD ERA

The fourth Earl of Chesterfield was appointed lord lieutenant of Ireland in January 1745 and is credited with initiating a series of landscape works, many of which were probably not completed until after his short tenure as lord lieutenant, having been recalled to London more than a year later. These included considerable replanting of the park as well as planting clumps of trees on either side of the main avenue and the erection of the Phoenix Column in 1747. He is also credited with throwing open the park to the public.

The dominant eighteenth-century managerial and infrastructural characteristics of the Phoenix Park were reflected by the extensive use of the Park by the military and the number of lodges used by government officers and other lesser officials involved in Park management. Apart from the use of the Park for military manoeuvers and practices, there were also a number of military institutions, which included the Royal Hibernian Military School (1766) for children who were orphaned or whose father was on active military service abroad. The Magazine Fort, constructed in 1736 with additions in 1756, was a major military institution around which the distributions of small arms, munitions and gunpowder to other military barracks in the Dublin area was central to its role.

Mountjoy Cavalry Barracks (formerly the home of Luke Gardiner, one of the Keepers of the Park) and the Royal Military Infirmary, were two further buildings constructed during the eighteenth century in 1725 and 1786 respectively. The role of the Salute Battery (for firing cannon on royal and others special occasions), situated in the environs of the Wellington Testimonial, was discontinued and the lands it occupied within the Park subsequently became known as the Wellington Fields and on which the Wellington Testimonial was erected.

All the important lodges and accompanying demesnes that were originally occupied by Park Rangers or Keepers were purchased for government use as private dwellings for the chief officers of state. These included the Lord Lieutenant, Vice-regal Lodge, the Chief Secretary's Residence (now the residence of the US ambassador to Ireland) and the Under-Secretary's residence, which subsequently became the residence and embassy of the Vatican and which now serves as the Phoenix Park's Visitor Centre.

The beginning of the nineteenth century saw the Park in a very neglected state, with poor drainage, roads in bad order and most of the trees in a state of decay and very old. However, with the Commissioners of Woods & Forests taking over the management of the public areas of the Park, and the employment of the renowned landscape architect Decimus Burton, all this was about to change. Burton produced a master plan for the Park, which included the building of new gate lodges, the removal and levelling of old hedgerows and shooting butts, tree planting in strategic locations, drainage, creation and re-aligning of the Park's roads, which included the main avenue or Chesterfield Avenue, and the restoration of the boundary wall. This latter project involved the relocation of the Phoenix Column on the main avenue. Burton's involvement for nearly two decades represents the greatest period of landscape changes since the Park's creation by the Duke of Ormond.

With the management of the Phoenix Park by the Office of Public Works in 1860, further improvements were undertaken, the first of which included the completion of the outstanding works associated with the Wellington Testimonial which was commenced in 1818. Two further memorials of considerable artistic merit were unveiled – one in 1870 commemorating the lord lieutenancy of the Earl of Carlisle, and the other an equestrian statue commemorating Field Marshall Viscount Gough, which was unveiled in 1880 – both of which were sculpted by John Henry Foley.

From the 1830s sporting and recreational activities began to take prominence, which was considerably reinforced from the 1860s onwards. The Royal Dublin Zoological Society opened Dublin Zoo in 1830. The Promenade Grounds opened in 1840 (later to be named the People's Flower Gardens) and were considerably improved in the 1860s with the addition of a Head Gardener's House, rock garden and horticultural facilites to allow for flower production for planting in the Gardens. Between the People's Flower Gardens and Dublin Zoo a bandstand and tearooms were built in the final decade of the century.

Although the military was dominant in the Park's institutions and Park use in the eighteenth century its influence was lessened somewhat in the nineteenth (though Mountjoy Barracks become the Irish headquarters of the Ordnance Survey Office in 1825), but the presence of the police become more prominent (which was welcomed), as is illustrated by the construction in 1842 of the Royal Irish Constabulary depot near the North Circular Road entrance to the Park and two police barracks – one at Ashtown Gate and the other at Parkgate Street. In 1848 the Commissioners of Woods & Forests further met their social obligations by providing for the educational needs of the Park's children by building a schoolhouse and teacher's residence to the designs of Decimus Burton.

THE TWENTIETH CENTURY

The history and landscape development of the Phoenix Park in the twentieth century is characterized by little infrastructural development except for considerable replanting of trees and shrubs that took place in the first decade primarily as a result of the great storm in 1903, responsible for the demise of nearly 3,000 trees. Another 10,000 trees were planted as part of the 1986 management plan and subsequent arboricultural works were carried out on the mature tree population.

The following pages set out an itinerary of the Phoenix Park, which includes the Park locations named by James Joyce in his writings about Chapelizod and its general environs.

CHESTERFIELD ROAD

Called after the fourth Earl of Chesterfield who was Lord Lieutenant of Ireland 1745-6. Chesterfield was responsible for the tree planting – groups of English Elms – on either side of the road and may have improved the construction of the road as well. Chesterfield Road divides the Park in two and extends from the Parkgate Gate Street entrance of the Park at the city end to Castleknock Gate at the opposite end – a distance of two and one-quarter miles. Decimus Burton, the famous English landscape architect, realigned the road as part of his monumental landscape works during the 1830s and 1840s. He had criticized the original road, saying that it was 'crooked and of little extent'. The scale of Chesterfield Road, referred to by Burton as the Grand Avenue, is monumental and consists of a central carriageway with a raised footpath on either side and separated from the carriageway by a sloping grass verge. Burton planted groups of red-twigged limes on either side and these were subsequently replaced in the 1890s by three rows of trees consisting of an outer staggered row of beech trees and the two inner rows – arranged in alternating pairs – of horse chestnuts and lime.

THE PEOPLE'S GARDEN

The People's Garden is located on the right-hand side of Chesterfield Road just inside the Parkgate Street entrance of the Phoenix Park. Evolved from the Promenade Grounds, made for public use and enjoyment in 1840 at the request of the Lord

Lieutenant at the time, Hugh Fortescue, Viscount Ebrington, in 1864 the Commissioners of Public Works announced that a flower garden was being developed at this location and would be available to the public the following year. As well as the new flower beds, additional walks and shrubberies were formed and many new trees were also planted. The garden's beauty derives from its natural setting with its ornamental lake and valley as well as its rock gardens. The seventh Earl of Carlisle along with William Spalding Wilkie is credited with developing the gardens in the 1860s and may explain why the Carlisle statue was erected there in 1870. A head gardener's lodge was erected in a picturesque location overlooking the ornamental lake in 1867 and some horticultural buildings for growing of plants and storage of flower bulbs. These gardens embodied the best floral traditions of the Victorian era and were extensively used for recreational purpose.

THE WELLINGTON TESTIMONIAL

On the opposite side of the People's Garden along Chesterfield Road is Europe's tallest obelisk (one time the tallest in the world) – the Wellington Testimonial. The 205-feet high obelisk (originally to be 220-feet tall) with the various victorious battles 'inscribed' on the faces of the testimonial was designed by Robert Smirke to commemorate the Duke of Wellington's victories. The foundation stone was laid in 1817 but the testimonial was never completed as intended. Four bronze reliefs were added to the faces of the testimonial's base designed by the leading sculptors of the day – J.R. Kirk, Thomas Farrell and John Hogan. The last panel has a verse composed by the Duke's brother, Richard, Marquis of Wellesley. Three pedestals – two for triumphal lions and one for the Duke of Wellington on an equestrian mount – which were part of the original design, were demolished before they could be adorned with the intended figures because of the lack of funds. The Duke served as prime minister of England from January 1828 until November 1830.

THE GOUGH STATUE

This statue was located on the first roundabout from the Parkgate entrance of the Phoenix Park but was removed in 1958 after it was damaged. Designed by Foley and Brock and erected in 1880 to commemorate Field Marshal Viscount Gough, this equestrian statue formed an excellent focal point as one entered the Park. In the early nineteenth century Gough was regarded as the greatest Irish soldier since Wellington and was praised by the Duke of Wellington for his part in the Sikh Wars. Winston Churchill's first coherent memory when he resided in the Phoenix Park was the unveiling of the Gough monument by his grandfather, the Duke of Marlborough, when he was Lord Lieutenant of Ireland.

THE HOLLOW

This is a natural amphitheatre located between Dublin Zoo and the People's Garden. It now houses a bandstand (erected there in the 1890s) and has been a popular location for performing bands including the Garda Band. It has also hosted cultural and sporting events and was a popular location and destination for tram journeys to the Phoenix Park for band recitals. In former times the Hollow contained a lake that was subsequently drained and planted with trees. The Hollow, like other ravines in the Park, is a result of glacial activities, but with the intervention of man, causeways were constructed thus creating features such as the Hollow. Another feature, also added in the 1890s, was the Tea Kiosk. Sited on the rim of the Hollow, this facility still proves popular with Park users today.

DUBLIN ZOO

Located between Áras an Uachtaráin and the Hollow and close to Chesterfield Road, Dublin Zoo is the fourth-oldest zoo in Europe after Paris, London and Vienna. Originally located on a piece of irregular ground of three and a half acres, it sloped down to a four-acre lake and had wonderful commanding views of distant scenery. It was decided to form the Zoological Society of Dublin in 1830 with a view to establishing a collection of living animals similar to London, which had opened in 1829. In July 1830 Decimus Burton, the designer of London Zoo, was commissioned to draw up plans for Dublin Zoo. Burton reported to the Society in 1832 – the report was accompanied by plans and several designs for houses. Since then Dublin Zoo has expanded to c.60 acres (30 of which were received from the Áras demesne in the 1990s). Almost one million visitors now come on an annual basis as a result of the considerable improvements and state investment since the mid-1990s.

THE DRUIDS ALTAR

The Druids Altar was one of three burial chambers located within the Phoenix Park, near the village of Chapelizod, before its removal to Dublin Zoo. It was relocated there when it was removed from its original location near the Park entrance at Chapelizod when gravel was extracted there in the 1830s and 1840s for Park construction. The burial chambers, one of which is still in its original location on Knockmary Hill, overlooking Chapelizod, are associated with Neolithic and Early Bronze Age man and were recently dated to 3300-3500 years BC. This leaves these cists older than those at Newgrange, Dowth and Knowth and the Egyptian pyramids.

THE STAR FORT

Also known as Wharton's Fortification and 'Wharton's Folly' because of its instigator the Duke of Wharton, who was Lord Lieutenant from 1708-10 and feared a rebellion. Shortly after commencement construction ceased on account of its cost. Originally built for security reasons, moated and constructed of earthen embankments, it was never completed and subsequently demolished by Decimus Burton's workforce of uemployed weavers in the 1830s and 1840s. Burton was conscious just how much it detracted from the beauty of the Park. So called because of its polygonal shape, it is frequently confused with the Magazine Fort, a construction that was commenced by the Duke of Dorset in 1735. The Star Fort occupied an area of nineteen acres and was used to grow grain crops because of its secure boundaries. The only vestige now remaining of the Star Fort is the small ornamental pond nearby, which takes its name from the fortification, and known as the Citadel pond and also as the Dog pond.

BEAU-BELLE WALK

This is the old name for the open circular area where the Phoenix Column was subsequently erected in 1747. Earlier in 1731 Mrs Pendarves (later Mrs Delaney) described this area as a promenading area for the beaux and belles of society. This area with its central ring, or rond, as they were called, formed the central open space of a landscape feature known as 'wilderness' and was laid out in a geometrical formation and dissected by straight paths, which usually converged on a central open circular area. The paths were usually aligned on some landscape feature as urns or statues.

THE PHOENIX COLUMN

The Phoenix Column was erected in 1747 at the request of the Earl of Chesterfield during his short tenure as lord lieutenant of Ireland. The Column is a thirty-foot high fluted Corinthian column of Portland stone mounted with a Phoenix aloft and with an inscribed base. The Column has been moved on a number of occasions as well as receiving additional features reflecting the period of time in which the additions were made or to create or enhance the pillar for a particular purpose. The pillar got its first lift and relocation during Decimus Burton's time in the 1840s when it was raised on a series of steps to create a more dramatic focal point for Burton's realigned Grand Avenue. In the 1860s the pillar got a Victorian makeover with the addition of a quatrefoil base and four pillars with truncated gas standards and lights with highly ornamental circular railings. The pillar was removed for the 1929 International Motor Car races and relocated to a grass area close to the entrance of Aras an Uachtarain. It was relocated yet again to the Burton position in the centre of Chesterfield Road in 1986 as part of the conservation management plan of the Phoenix Park to reinforce its historic character.

VICEREGAL LODGE

The Viceregal Lodge and demesne is the largest of the enclosed demesnes within the Phoenix Park. Originally it was the abode of Nathaniel Clements, who was the head ranger of the Park before it was relinquished to the government in the 1780s, to become the residence of the viceroys or lord lieutenants of Ireland, before becoming in turn the residence of the presidents of Ireland and now known as Aras an Uachtarain. Its main entrance is strategically located near the Phoenix Pillar and is accessed through a fine ensemble of gates and railings with two flanking guard houses or gatelodges designed by Decimus Burton in 1842. It was occupied by Tim Healy as the first Governor General of the Irish Free State in 1922. Queen Victoria resided here during her visits to Ireland and planted a number of ceremonial trees including a Wellingtonia or Californian Redwood on the South Lawn in 1861, which is visible from Chesterfield Road. It was from the window of the Viceregal Lodge that Earl Spencer the Lord Lieutenant of Ireland witnessed the murder of both his Chief Secretary, Lord Frederick Cavendish, and his Undersecretary, Thomas H. Burke, on Chesterfield Road. A cross, cut from the grass verge, marks the spot where the murders took place.

FIONN UISCE SPRING

Most local historians and place-name authorities agree that the word 'Phoenix' as applied to the Park is a corruption of the Irish 'fionn-uisce', which means clear or limpid water. Dr Joyce, who is the leading place-names authority, believed that it was a spring of clear water located in the sunken fence of the Viceregal Lodge near the Phoenix Pillar. Confusion about its location is caused by the fact that it becomes mixed up with the Spa Well, located on the northern boundary of Dublin Zoo and also the stream of clear water runs down the Khyber valley beneath the Magazine Fort. Two other spring wells within the confines of the Magazine Fort further confuse the origin of the fionn-uisce well.

CHIEF SECRETARY'S LODGE

The Chief Secretary's Demesne and Lodge (known as Deerfield House) is the second-largest of the Park's enclosures and again its main entrance is accessed at the Phoenix Pillar on Chesterfield Road. It was the home of successive Chief Secre-

taries of Ireland since Sir John Blacquiere took up residence there in 1774. The arched entrance with twin gate lodges, probably to the designs of Jacob Owen and gates by the famous iron founder Richard Turner, make an imposing entrance to the demesne. Sir Robert Peel resided here when he was Chief Secretary for Ireland, 1812-18. Ninian Niven, the foremost Victorian landscape professional, worked in the Chief Secretary's gardens from 1827 to 1834 before becoming curator of the National Botanic Gardens at Glasnevin in Dublin. Lord Cavendish was brought here after his tragic death on Chesterfield Road in May 1882. Spectacular panoramic views are to be had from the front lawns of the demesne to the broad acres of the Phoenix Park and to the Dublin Mountains. Like the Viceregal Demesne, the grounds of the Chief Secretary's Demesne have also become a repository for ceremonial trees, two of which were planted on the front lawns by the Prince and Princess of Wales in 1868. The Chief Secretary's Demesne and Lodge is now the residence of the American Ambassador to Ireland.

UNDER-SECRETARY'S LODGE

The Under-secretary's Demesne is also accessed from the Chesterfield Road at the Phoenix Pillar and is the smallest of the three demesnes and has been home to successive under-secretaries for Ireland since the 1780s. One of the oldest buildings in the Park is Ashtown Castle, which became the residence of the keeper of Ashtown Walk from early in the Park's history before the tower of the castle became incorporated in 1760 into a new house, which became known as Ashtown Lodge. The longest serving Under-secretary was the Rt Hon William Gregory who resided here from 1812 to 1830. It was also home to Thomas Henry Burke, who was murdered on his way home to this residence in 1882. It became the residence of the Papal Nuncio to Ireland in the 1930s and remained so until 1978 when it was vacated and the Nuncio moved to a new Papal nunciature on the Navan Road. It was to these gardens and grounds that William Spalding Wilkie came as a young highly recommended gardener from Woburn Abbey in England in 1816. This demesne charts precisely the evolution of the walled garden and now hosts the Phoenix Park's Visitor Centre.

BUTCHER'S WOOD

This perimeter woodland belt is located along the Park wall between Castleknock Gate and White's Gate and is referred to as Butcher's Wood in Sheridan Le Fanu's *The House by the Churchyard*. It derived its name from the bloody encounters between the various butchers' guilds when they fought for supremacy to decide which was the leading guild. This was one of the first woodlands to be interplanted by Decimus Burton when he undertook major landscape works in the Phoenix Park in the 1830s and 1840s.

MOUNTJOY BARRACKS

Formerly the home of Luke Gardiner when he resided there as Keeper of Castleknock Walk. By 1812 the house and lands had been acquired for Mountjoy Cavalry Barracks (one of whose duties it was to provide the mounted escort for the lord lieutenant) and later became the centre for the Ordnance Survey of Ireland in 1825 when it was handed over by the Board of Ordnance. The Barrack Demesne, as is was known, had a considerable amount of land attached to it (and was used by the lord lieutenants when in office), which Woods & Forests successfully managed to have reduced and the remainder put into the Park for public use. An array of meteorological instruments was located in the southern end of the garden, which allowed continuous meteorological data to be collected there since 1829.

THE FURRY GLEN

The Furry Glen is variously referred to as the Furzy Glen and the Fairy Glen – the former denoting the growth of furze, gorse or whins there and the latter possibly denoting the growth of hawthorn trees (for which the Park was noted) with their fairy associations. Decimus Burton, the famous English landscape architect, considered this area to be one of the most attractive in the Park and had the Glen pond constructed by damming it at its present location. The Furry Glen is one of many natural glens or ravines formed by glacial activity along the southern boundary of the Park. This area is designated as a wildlife refuge and is maintained as one of the natural areas of the Park.

THE FIFTEEN ACRES

This large area of the Park, located on the south side of the Phoenix Park, is really a misnomer since this flat plain is more like 300 acres than 15 acres. It was famous in the eighteenth and nineteenth centuries for military reviews, manouevres, encampments and artillery practice by the military and also for the settlement of gentlemanly disputes by means of duels. Nowadays team sports and informal recreation take place there as well as grazing for herds of fallow deer. The derivation of the name fifteen acres is explained by Sheridan Le Fanu in *The House by the Churchyard*, where he explains that the location of the former artillery butt formed 'the centre of a circular enclosure containing just fifteen acres'. Howwever, it was originally an area of fifteen acres where the Papal Cross now stands where military exercises were carried out.

The Magazine Fort was constructed on St Thomas's Hill on the site of Phoenix House, which was demolished on the Duke of Dorset's instructions to make way for the fort. It was built to house gunpowder and other munitions for the Dublin garrisons. In 1801 Francis Johnston, the Board of Works architect, added on a triangular brick extension to house the personnel from the artillery barracks, which had relocated from Chapelizod. The original fort was guarded by twelve 24-pounder cannons strategically placed around the Magazine walls. The Magazine Fort attracted the attention of Dean Swift, who was walking in the Park and composed the following verse:

> Behold a proof of Irish sense,
> Here Irish wit is seen,
> When nothing, left that's worth defence
> We build a magazine.

The Magazine was raided on two occasions – once in 1916 and again in 1939. On the first occasion it was to signal the 1916 but this not go as intended and on the second occasion a considerable amount of arms and munitions were stolen but these were retrieved shortly afterwards.

Chief Park Superintendent of OPW

SHERIDAN LE FANU AND GREATER CHAPELIZOD

W.J. Mc CORMACK

One of the merits usually ascribed to *The House by the Churchyard* (1863) is the novel's pleasing focus on a single location, the village of Chapelizod to the west of Dublin city. No sooner has this factor been confirmed than it should be modified, according to Einstein's laws of relativity. That is to say, space cannot be isolated from considerations of time, and so the fictive 'closed room' or self-contained mystery of the novel is discovered to be riddled through with temporal (even historical) forces originating elsewhere and irresistible even in Chapelizod. Sheridan Le Fanu admits as much in the opening pages of his novel, though he does so misleadingly through invocations of a pre-industrial 'earlier' village preserved in the Pax Hibernica of the mid-eighteenth century, and contrasts this with the village as his readers will know it in the 1860s.

The fluidity of setting in *The House* can be further appreciated if one compares it with Le Fanu's first venture into print as a novelist. In 1845, *The Cock and Anchor* exploited several locations used in the later work including 'the little town of Chapelizod'[1]. Within the conventions of the post-Scott historical novel, and set in the early years of the eighteenth century, this debut long fiction employs Chapelizod as the place where the confessional identity of a priest, member of a tonsured order, is established for the novel's Catholic hero. The novel of 1863 accommodates a far more compliant priest in Chapelizod, while the village itself is presented as a bastion, even model, of the Protestant establishment. Published between these two novels, *Ghost Stories of Chapelizod* and *Some Gossip about Chapelizod* provide a slender foot-bridge from the fiction preceding the traumatic events of 1848 to that of Le Fanu's most secure decade as minor press baron and prolific novelist.[2]

There are other reasons for considering *The House* in a context wider and longer than that officially pronounced. In practice, the novel's location is in no perspective limited to the streets, taverns and ecclesiastical buildings of Chapelizod in 1767. Repeatedly, the great expanse of the Phoenix Park is implicated in the comings and goings of villagers and, beyond the Park, the Irish capital where the political and military administration of the country is centred. Joycean scholars were the first to point out the essential connection: 'like *Finnegans Wake*, *The House by the Churchyard* is a story about events in two places'.[3] Within the Park, the modest lodge was erected by the park ranger in its earliest form between 1752 and 1757, that is, ten to fifteen years before the fictional events of *The House*.[4] By the time of Le Fanu's writing his novel, the house had undergone major developments and aggrandisements, having become the official residence

[1] J.S Le Fanu, *The Cock and Anchor, Being a Chronicle of Old Dublin City*, ed. Jan Jedrzejewski. (Gerrards Cross: Smythe, 2000), p. 235. The editor reprints the text of *Morley Court*, a revised version of the novel published in one volume by Chapman and Hall of London; he provides the textual variants in appendix form.

[2] These short pieces appeared anonymously in *The Dublin University Magazine* of January and April 1851 respectively; see Appendix 1 of W. J. Mc Cormack, *Sheridan Le Fanu and Victorian Ireland.* (Oxford: Clarendon Press, 1980)

[3] James S. Atherton, *The Books at the Wake; a Study of Literary Allusions in James Joyce's* 'Finnegans Wake.' London: (Faber, 1959), p. 111.

[4] Christine Casey, *The Buildings of Ireland; Dublin, the City within the Grand and Royal Canals, and the Circular Road, with the Phoenix Park.* (London: Yale University Press, 2005), p. 294.

of the Lord Lieutenant (now the presidential residence, Áras an Uachtaráin). This domestication of the ruling bureaucracy between mid-eighteenth and mid-nineteenth century should be considered in several lights: it is a measure of the slow incorporation of west Dublin villages (like Chapelizod, Palmerstown etc.) into the metropolitan orbit; it is also a symbol of growing official confidence in the successful pacification of Ireland after the insurrections of 1798 and 1803. Paul Dangerfield, chief villain of Le Fanu's novel, occupies a position not unlike that of a Lord Lieutenant in petto. Once the manager of estates in England, he has come to Ireland to oversee his employer's Irish possessions. While he stalks through the village of 1767, he mimics in advance the role of the Victorian chief governor, resident next to Chapelizod in the Phoenix Park.

Originally, the Phoenix Park had been a royal hunting ground, its southern boundaries lying well beyond the Liffey banks. When the Royal Hospital (a refuge for aged and infirm army veterans) was built in 1680, the effect was to establish the river as the Park's southern frontier. But the underlying social topography of the area should be seen as including, not only the village of Chapelizod to the west, but also the grounds of several institutions now dominating the southern bank. These include the Royal Hospital (now the Irish Museum of Modern Art), Dr Steevens's Hospital (now headquarters of the Health Service Executive), and Saint Patrick's Hospital (founded by the will of Jonathan Swift). Indeed, official confidence in the security of Dublin was expressed as early as 1706, when plans were drawn up for an open-plan barracks on the north side of the Liffey, close to the eastern boundary of the Phoenix Park. It is from this initiative than one can date the gradual emergence of a west-urban cluster of official buildings and institutions for which Chapelizod served as a kind of entrance-gate on the rural side. Le Fanu insists in *The House* that the village was home to the Royal Irish Artillery, but it is worth noting in addition the construction of another (replacement) barracks in 1798, not far downstream at Islandbridge. The security of Irish administrations was recurrently a relative matter. And the nervous repetitive manner in which security was proclaimed, only to be found inadequate (inwardly or outwardly), contributes both to the theme and technique of Le Fanu's novel.

In the surviving Le Fanu family archive, the most voluminous commentary on the Victorian phase of these developments is provided by the diary of the novelist's brother, William Richard Le Fanu (1816–94), a successful railway engineer and public administrator. Indeed, the novelist's security in the 1860s depended substantially on loans obtained from his more worldly brother.[5] Much of William's business was connected with the development of railway services out of King's Bridge station in Dublin. Completed in 1847, this elegant building further added to the growing importance of the area immediately south of the Phoenix Park while, paradoxically perhaps in Le Fanu-esque terms, also adding to the isolation of Chapelizod at the Park's south-western corner. In September 1847 Sheridan Le Fanu's nervous wife, Susanna, vetoed a plan the brothers had hatched to travel together by train to Cork, but we may confidently assume that he used the King's Bridge lines on other occasions. To take one example relevant to scenes in *The House*, when the brothers' mother (Emma, née Dobbin) died in March 1861, she was buried in the County Limerick graveyard where her husband had lain since 1845. It is likely that the body was conveyed to Limerick Junction (if not farther) by a train which skirted the village of Chapelizod after it had left King's Bridge. Certainly William travelled to the funeral by rail on 14 March and returned to Dublin later in the same day.[6] Oddly enough, the diary fails to mention Sheridan Le Fanu in its very brief account of the day's events.

In the 1860s William Le Fanu often used the Phoenix Park for recreation, either walking its broad acres or visiting the Zoological Gardens within it. Since the beginning of the previous decade, a further point of call in the district was Dr Steevens's Hospital, an eighteenth-century foundation lying immediately south of the railway station where he attended frequent planning or administrative meetings. A cousin, the Revd William Peter Hulme Dobbin (1820–71), held the miserable post of chaplain since 1851, living on the hospital premises with his family and against his will. Dobbins and Le Fanus had been intimate even before the marriage of the brothers' parents in 1811; the Revd T. P. Le Fanu had been curate under Dr William Dobbin in the parish of Saint Mary, Dublin. Dr Dobbin's family was said to have had radical associates including the United Irishmen, John Sheares and Robert Emmet, both of whom died on the scaffold. Later generations were known for eccentricity, though the young Sheridan Le Fanu had banked on Dobbin connections in London's publishing world – fruitlessly, it seems.

[8] See Mc Cormack, *Sheridan Le Fanu and Victorian Ireland,* pp. 117, 136-7.
[9] TCD MS 7701. Diary of W.R. Le Fanu, 1861, 14 March.

The chaplain in Dr Steevens's Hospital had married Fanny Le Fanu Knowles, and the couple imposed the (middle) name Le Fanu on two of their offspring at baptism, with Sheridan serving in a third case. Despite these inscriptions of distinguished kinship, the family suffered much social humiliation. The couple was more than once reprimanded for the slovenly maintenance of their rooms or thoughtless behaviour. In 1862 the matron complained 'of the constant annoyance and disturbance caused her by the noise made by Mr Dobbin's children over her head, and some years later the Committee directed the chaplain 'to prevent in future the disfigurement of the gallery by having the top of the windows stuffed with old clothes'. The Revd W.P.H. Dobbin was able to supplement his stipend with a little teaching as the grandly named Professor of Logical Science at a medical school attached to Dr Steevens's and drawing on the resources of neighbouring Saint Patrick's (mental) Hospital. But it is not unlikely that the chaplain was (like the novelist) a beneficiary of William Le Fanu's bounty.

Let us return to Chapelizod without entirely forgetting Dr Steevens's Hospital downriver. The second chapter of *The House by the Churchyard* recounts the furtive burial of a second coffin in a vault of Chapelizod church; apart from the furtiveness, the event recalls the burial of Mrs Emma Le Fanu (née Dobbin) in her husband's vault six months before her son's novel began serialization in the magazine he had acquired with funds loaned by her other son. The rector who presides at the fictional interment was named Walsingham, and he is described 'now lost in the darkness – now emerging again' in a manner that suggests a 'clerical portrait'. Two forensic details of this miniature portrayal of Chapelizod's fictional rector should be noted – (1) he bears a recognizably eminent historical name; (2) the technique of describing him in terms of lighting (now in darkness, now emergent into view) recurs equally early in Le Fanu's best known novel, *Uncle Silas* (1864). The latter's narrator describes her father walking in his library, 'at the far end he nearly disappeared in the gloom, and then returning emerged for a few minutes, like a portrait with a background of shadow'. [10]

'Something Crosses an Empty Room' – the sub-title of Chapter 74 in *The House,* catches at what might be pompously called 'the ontological indeterminate' in Sheridan Le Fanu. James Walton has brilliantly explored his constitutive metaphors of vision and vacancy, but the point at issue here lies between novels rather than being internal to either.[11] That is to say, the 'portrait' metaphor links the Revd Hugh Walsingham and Mr Austin Ruthyn of Knowl, where almost everything else in the texts speaks against any resemblance. In *Uncle Silas*, the metaphor is pressed so hard that a portrait is found on the wall at Knowl, as if projected, which the portrait-like Austin describes as a representation of his brother, Silas, in youth.[12] *The House by the Churchyard* employs a different form of duplication in which the fictional and the actual participate: this is the use of historical names, modified yet identifiable. The mild-mannered eighteenth-century rector in a nineteenth-century novel bears the surname of an Elizabethan secretary of state. Though distinctive name-shadows could be pursued, it may prove unexpectedly rewarding to look at a less than distinctive – positively absent – one.[13] At the end of Chapter 49, a minor character 'ordered his man to take his compliments to Captain Burgh and Lieutenant Lillyman, the tenants of the nearest lodging-house, and to request either to come to him forthwith on a matter of life or death'.

Lillyman 'was at home, and came'.[14] In the novel's highly complicated and self-obfuscating plot, this incident is of little significance, and one might wonder why Captain Burgh was ever mentioned, as his absence, when called upon, is strongly implied. Perhaps his name should be added to Walton's tally of absences, were it not for the possibility that Le Fanu's use of the name points elsewhere. It is not an allusion in any substantive or material sense; indeed, if it retains

[7] T. Percy C. Kirkpatrick, *The History of Doctor Steevens' Hospital, Dublin, 1720-1920.* 2nd ed. (Dublin: UCD Press), 2008. pp. 79, 253.

[8] See J.B. Leslie and W.J.R. Wallace (eds), *Clergy of Dublin and Glendalough; Biographical Succession Lists.* (Belfast: The Ulster Historical Foundation, 2001), p. 580.

[9] J.S. Le Fanu, *The House by the Churchyard* (with an introduction by Elizabeth Bowen). (London: Anthony Blond, 1968), p. 12. No scholarly edition of the novel has been published. Of the two clergy actually serving in Chapelizod at the loosely indicated time of the novel's setting, John Jourdan (died 1758) deserves attention for his role as chaplain to Lord Galway on a mission to Portugal in 1704, the length of his incumbency in Chapelizod from 1741 until death, and his marriage to the daughter of Elias Bouhereau, first keeper of Archbishop Marsh's Library. These Huguenot and scholarly associations were appreciated by the novelist; see *Clergy of Dublin*, p. 781.

[10] J.S. Le Fanu, *Uncle Silas, a Tale of Bartram-Haugh* (ed. W. J. Mc Cormack), (Oxford: Worlds Classics, 1981), p. 2.

[11] James Walton, *Vision and Vacancy; the Fictions of J. S. Le Fanu.* (Dublin: UCD Press, 2007).

[12] Because it would take us away from Chapelizod, I don't want to repeat here – though it is thematically relevant – the argument adduced in the fifth chapter of *Sheridan Le Fanu and Victorian Ireland* to show that Silas *is* Austin spiritually exposed or displayed.

[13] Other names in the novel include Chattesworth, Devereux, Drayton, Loftus, Mervyn; for a discussion of Le Fanu's nominalism see Mc Cormack, *Dissolute Characters; Irish Literary History through Balzac, Sheridan Le Fanu, Yeats and Bowen.* (Manchester: Manchester University Press, 1993), pp. 36-7.

[14] *The House* , p. 230.

or acquires any sense at all, this is more likely to emerge in further discussion of *Uncle Silas*. And to pursue that objective, one must return to Dr Steevens's Hospital.

As things stand at present, no evidence is available to prove that the novelist ever set foot in the building. However, certain associations might be noted. At an early stage of his professional career as a physician, the novelist – and sometime editor of *The Dublin University Magazine* – Charles Lever walked the wards of Dr Steevens's. Lever published Le Fanu's gruesome story, 'Spalatro' (1843) in the *DUM*. In the 1850s and later, Le Fanu's double-cousin lived in the hospital, and was unquestionably visited by William Le Fanu. The remarkable Edward Worth Library, preserved in what had become the hospital board room, contained numerous rare works of alchemy, astrology and occultism of the kind that are alluded to in Sheridan Le Fanu's more arcane fictions. For example, the library holds four texts by Van Helmont whose name features in *The House by the Churchyard*. Happily for Le Fanu, there were two Van Helmonts, of the same family.[15]

In the fifth chapter of *The House*, Chapelizod's rector is present at a regimental dinner of the Royal Irish Artillery with, rather improbably, the village's Catholic priest also in attendance. Dr Walsingham attempts to cast light on a then current philosophic-scientific topic:

> There is, my Lord Castlemallard, a curious old tract of the learned Van Helmont, in which he says, as near as I can remember his words, that magnetism is a magical faculty, which lieth dormant in us by the opiate of primitive sin, and therefore, stands in need of an excitator, which excitator may be either good or evil, but it is more frequently Satan himself, by reason of some previous oppignoration [i.e. pledge or compact] with witches. The power, indeed, is in the witch, and not conferred by him; but this versipellous [i.e. capable of changing form] or Protean imposter – these are his words – will not suffer her to know that it is of her own natural endowment, though for the present charmed into somnolent inactivity by the narcotic of primitive sin.[16]

As the narrator admits, the rector's summary of Van Helmont is likely to send the reader asleep as quickly as it did Lord Castlemallard. As quoted by Walsingham, Van Helmont anticipates themes of the novel into which he is introduced with a suitably theological emphasis, while also providing a description of the novel's ultimately exposed villain as a 'Protean imposter'. But if one accepts *A Ternary of Paradoxes* (London, 1650) as Van Helmont's work, then the Brussels-born alchemist links magnetism to a magical theory of cures for wounds caused by knives and swords, even more central to crimes lying behind *The House*.[17] Accepting that balms should be applied to the wounding metal rather than the wounded flesh, Van Helmont might be regarded as a forerunner of that homeopathic medical heresy that wreaked havoc in Sheridan Le Fanu's household.[18] *The Ternary*, however, is not to be found in the Edward Worth Library, nor in Marsh's Library to which John Jourdan (see note 9 above) had easier access.

Visitors to the chaplain of Dr Steevens's Hospital were likely to be shown the board room which, according to tradition, was never locked (though the bookcases were protected by locked glass doors.) Visually, the room was dominated by a large portrait of Edward Worth, hung over the black marble fireplace. With its narrow, shuttered windows, the library possessed features replicated in the opening pages of *Uncle Silas*. However, if the visitor reached the chaplain's meagre apartment on the top floor, she would have a view into the Hospital inner quadrangle or courtyard. *Uncle Silas's* narrator offers this:

> Milly [her cousin], however, knew a queer little, very steep and dark back stair, which reached the upper floor; so she and I mounted, and made a long ramble through rooms much lower and ruder in finish than the lordly chambers we had left below. These commanded various views of the beautiful, though neglected; but on crossing a

[15] These were Jan Baptiste (1577-1644) and his son, Francois-Mercure (1618-99); see Allen G. Debus, *Chemistry and Medical Debate; Van Helmont to Boerhaave.* (Canton, MA: Science History Publications, 2001), pp.32-51.

[16] J.S. Le Fanu, *The House*, pp. 29-30. The emphasis on primitive (ie original) sin in this fictional summary reflects the enduring Calvinism of Huguenots, even after incorporation into the Church of Ireland, though Van Helmont was a Catholic.

[17] The notion of a 'weapon salve', often ascribed to Paracelsus, can be traced earlier than Van Helmont who became involved in opposition to a Jesuit; see Debus, op. cit. p. 36. In some respects it is an attempt to answer the dilemma of Philoctetes; in others it anticipates the cynico-profound machinations of Wagner's *Parsifal* (1882).

[18] See pp. 129-134 of Mc Cormack, *Sheridan Le Fanu and Victorian Ireland*, for an account of the novelist's interest in homeopathy and of the interconnections with religious scepticism. After Susanna's death in 1858, Le Fanu kept a brief diary that recorded a dream of his wife's in which her dead father lays his hand on her bed-clothes, an incident expanded upon in Chapter 12 of *The House*.

gallery we entered suddenly a chamber, which looked into a small and dismal quadrangle, formed by the inner walls of this great house, and of course designed only by the architect to afford the needful light and air to portions of the structure.

I rubbed the window-pane with my handkerchief and looked out. The surrounding roof was steep and high. The walls looked soiled and dark. The windows lined with dust and dirt, and the window-stones were in places tufted with moss, and grass, and groundsel. An arched doorway had opened from the house into this darkened square, but it was soiled and dusty; and the damp weeds that overgrew the quadrangle drooped undisturbed against it. It was plain that human footsteps tracked it little, and I gazed into that blind and sinister area with a strange thrill and shaking.[19]

It would be foolish to announce Dr Steevens's Hospital as an 'original' of Uncle Silas's country house at Bartram-Haugh or to re-introduce a quasi-biographical method of literary analysis. A more fluid historical approach is preferable, one that acknowledges both the non-congruence of *The House by the Churchyard* with its attention to the village of Chapelizod and the collocation of unrelated local traces in *Uncle Silas*. Opened to patients in 1733, Dr Steevens's Hospital lay in extensive grounds, with a wooded hill to the east, pasture to the north and west, and riverbank (more exactly, lack of bank) to the north. By the time of the Revd Dobbin's unhappy service as chaplain, Saint Patrick's Hospital, Guinness's brewery, and King's Bridge railway station had encroached, with a Victorian nurses' home and laundry added closer still for good measure. Trams or streetcars bundled travellers indiscriminately together.[20] The architectural grandeur of the original hospital in its extensive grounds was in the 1860s much cluttered around and, internally, neglected not least by the novelist's cousin. The original architect, and hospital trustee, was a military engineer, named Burgh.[21]

If one allows that the Hospital, the railway station, the Phoenix Park and the village of Chapelizod by this date all interacted socially and economically, then a final glimpse might be directed towards *The House by the Churchyard*, with a view towards finding traces of the same implication blazoned on Le Fanu's title-page of 1863. While the novel emphasizes the parish church's centrality in village life, and also in concealed occurrences preceding the events occupying most of its pages, the title borrows directly from Jonathan Swift, whose poem 'On the Little House by the Churchyard' related, however, not to Chapelizod but to Castleknock, to the north-west of the Park.

Swift mattered to Sheridan Le Fanu. As a young man, he had published two small collections of 'Original Letters', the first consisting in two letters by Swift, which had come to him through the Sheridan family, and the second in Jacobite material passed down through Dr William Dobbin, the novelist's grandfather.[22] Swift makes what may be his first appearance in fiction in *The Cock and Anchor*, serving to excoriate a corrupt chief governor. In *The House*, the Christian name of Swift's Gulliver features very early, if not clearly.[23] These are traces, but not tracks to be followed to some one conclusion. More pervasive yet less easily pinpointed is the great issue of Swift's condition in his last years, madness, or the relation of mind and body, later provided for under his will by which a hospital for 'the fools and mad' was built in the upper grounds of Dr Steevens's Hospital. Swift, with Thomas Burgh and others, had been a trustee of the hospital project after Richard Steevens's death.

The mind-body problem, sometimes the plaything of philosophers, is not to be identified with the body-and-soul issues of religion. But in Le Fanu the two are brought into proximity when medicine and theology enter together, as with Dr Bryerly, the Swedenborgian of *Uncle Silas,* or the characters and narrators who animate the stories of *In a Glass Darkly*. Le Fanu's Chapelizod fiction, however widely defined, does not present a clear-cut example, though there are suggestive hints and double hints, as when the 'murdered' Dr Sturk is revived by a rogue surgeon employed to finish him off. The villain is exposed as Charles Archer of old, whose new name, Dangerfield, could be taken as connoting the wider stage upon which the villagers act out their lives. Chapelizod has its rival medical men (Sturk and Toole), and its rival parsons (Walsingham and Roche); so too the ultimate villain has rival names, Archer and Dangerfield. In *The Cock*

[19] J.S. Le Fanu, *Uncle Silas* pp 212-13.

[20] For a helpful account of the city in Le Fanu's last years, see the early chapters of Mary E. Daly, *Dublin: the Deposed Capital; a Social and Economic History 1860-1914.* (Cork: Cork University Press, 1984.)

[21] For an account of Thomas Burgh (1670-1730), whose father (like the novelist's) had been some time Dean of Emly, see *Dictionary of Irish Biography* (2009). In Kirkpatrick's account of the building work, the architect is referred to simply as 'Captain Burgh'; see, p. 69.

[22] For further details of the material, see Mc Cormack, *Sheridan Le Fanu and Victorian Ireland*, pp. 89-90.

[23] Le Fanu, *The House*, p. 5.

and Anchor and *The House*, as in *Finnegans Wake*, the Phoenix Park constitutes a field of mortal danger, not simply a place of conspiracy and assault, but of both over-determined and dissolving actuality.

In *Uncle Silas* Le Fanu brought these preoccupations into a more orderly form, employing (by implying) the doctrines of Swedenborgianism for an encompassing structure. The house built around an inner quadrangle has its claustrophobic dimension, linked ostensively to the plot of imprisonment and enclosure to which the incidents of interment obviously relate. In keeping with its double – or correspondence – structure, there are two scenes of viewing to be contrasted, the first being that in which Maud looks into Bartram's inner quadrangle. The second also involves the narrator, though to very different effect. On this occasion, she is looking outwards from the house towards the overgrown approaches, and attempting to identify a new nocturnal arrival:

> I was obliged to keep my cheek against the window-pane to command a view of the point of debarkation, and my breath upon the glass, which dimmed it again almost as fast as I wiped it away, helped to obscure my vision. But I saw a tall figure, in a cloak, get down and swiftly enter the house, but whether male or female I could not discern.
>
> My heart beat fast. I jumped at once to a conclusion. My uncle was worse – was, in fact, dying; and this was the physician, too late summoned to his bedside.[24]

It may be characteristic of Maud's personality that she jumps to a morbid conclusion, but the less psychological implications are the more important. Though now looking outwards, her vision is no less enclosed, this time frustrated by her own natural bodily function of breathing. Claustrophobia, like the portrait of a second Ruthyn in Maud's childhood home, is a projection, a kind of self-portrayal. Her panicky assumption that the nocturnal visitor is a medical person – inconsistent in the 1860s with her inability to decide whether it was male or female – neatly keeps the spiritual and the bodily realms in close proximity.

The Chapelizod fictions, beginning with *The Cock and Anchor*, including the short pieces of 1851, and culminating in *The House*, investigate several proportionalities of Irish sectarian conflict, but also reach out to the larger political opposition (variously measured) between Ireland and England or Britain. Thanks to Walter Scott, the first novel aligns the conflicting parties to sexual identities, in keeping with a romantic formula. Other problematic binaries, most obviously that of outer and inner worlds, link up with philosophic-medical concerns, which, for Le Fanu, were most appealing in the work of Swedenborg and Van Helmont, and in the congeries of theory and treatment laid forth in *In a Glass Darkly*, where the conventional binary of sex is disrupted throughout 'Carmilla'. Homeopathy, a topic of non-unanimity in the Le Fanu household, adds a different dimension to binarism, with its tinctures and sympathies.

The Van Helmonts, homeopathically cited once in Le Fanu's fiction, may be correspondingly important and influential. Father and son both employ the idea of paradox to define their focus.[25] From *The House*, Joyce gratefully purloined the imagery of river and stone, or river and 'yonder elm'. Jan Baptiste Van Helmont had conducted an experiment centuries earlier with a willow tree, proving that water was the 'prima materia', that earth as an 'element' was secondary.[26] *The House by the Churchyard*, though its title derives from Swift, presents another binary of great importance for Wagner, Yeats, Joyce and others – that of habitation and interment, life and death. River, tree, stone, house and churchyard all occupy positions in the wider danger-field. Le Fanu, as a visitor to Derbyshire (where part of *Uncle Silas* is set, not to mention other fictions of his such as *The Wyvern Mystery*) may have noted that the King's Bridge railway station, opened in 1847, echoed in some of its detail Robert Adam's great country house at Kedleston. That is mere life and mortar. The Van Helmont-quoting Dr Walsingham lived in the house by the bridge, at the eastern extremity of Chapelizod.

Biographer of Sheridan Le Fanu

[24] J.S. Le Fanu, *Uncle Silas*, p 220.

[25] In addition to JB. Van Helmont's *Ternary of Paradoxes* (1650), note FM Van Helmont's *Paradoxical Discourses . . concerning the Macrocosm and Microcosm and the Greater and Lesser World and their Union* (London, 1685).

[26] Debus, op. cit. p. 41.

THE STRANGE CASE OF THE DISAPPEARING BREAD–
Balancing the Book(s) – Leopold Bloom's Budget for 16 June 1904

DANIS ROSE

What I want to look at, and look at closely, is a small section of the text of *Ulysses* – less than a page in fact – that one encounters late in the day as Bloom, his wanderings shadowing him, begins the process of di(s)vestiture in preparation for sleep, personal oblivion, and literary immortality. The section is of compelling interest in a number of ways. It functions not only as another passage through which the narrative is moved on a little, but it also illustrates a characteristic signature of Joyce's style of writing: the interconnectedness of the part with the whole, the degree to which the part is conditioned by and conditions the whole in a kind of dynamic and osmotic inner reflexivity, and the degree to which Joyce was able to attain and sustain this delicate balance with its conflicting concerns and disparity of scale between subtexts, narrative and narrated detail.

The issue of the internal balance that one finds written into *Ulysses* ultimately determines the micro-structural coherence of the book. It imparts to the text in progress a kind of internal logic of its own that, once it is in place, restricts the freedom of the author in its further development, much like the evolution of the stars that, although initially open and thereby lacking strict pre-determination, at the same time expresses itself in its synchronic unfolding in limited coherent states predicated not alone by the strictures imposed by the laws of physics, inexorable once they have emerged, but also by the contingencies of the past history of the cosmos. Thus, not to put too abstruse a tooth on it, in *Ulysses* Corley's genealogy as outlined in 'Eumeus' is predicated (by the author's self-minded personal consistency) by that narrative context already present in Joyce's pre-existing *Dubliners* story, 'Two Gallants'.

This kind of anastomotic cohesiveness is ubiquitously pertinent to the potentiality of *Ulysses* as Joyce constructed/wrote it and narrows down what the author can do next with the text once it has reached a certain critical mass. From this the question arises whether or not, in certain instances, the so-called internal logic of the book can be appealed to in making editorial decisions regarding the wording of the text. In other words, is *Ulysses* so carefully constructed that its inherent requirement for referential coherence supersedes the authority of the manuscript record, and does this requirement imply a global authorial intention, a golden rule or law, even if it was not fully realized in the actual historical production of the text? This consideration leads us directly to the question of the status of a work of art such as *Ulysses* – to what extent can and should it be divorced from its author (a state of detachment that Joyce himself argued was essential for the work to be wholly integral). The textual scholar can ask: which takes precedence: *Ulysses* or James Joyce? If *Ulysses* had been published anonymously, would it be the same work?

It may be that no conflict arises. It may be that the text of *Ulysses* as historically produced is coherent in all its dimensions and concerns and that Joyce was the master craftsman in practice as well as in conception and that there is no difference, at any level of detail, between the text as he conceived it and the text as he physically wrote it out.

Before I proceed to illustrate how Bloom's budget can help us to answer the above questions and can illustrate the difference between the work of art as it could and should be and the work as it has historically come down to us, and from there lead us into the debate of the desirability of emending the latter to attain the former, let me point out that

Ulysses, as embodied in its much-vaunted first edition, is something of a mess at the level of fine detail. It abounds in errors of one kind or another, of which only a few were ever detected/corrected by Joyce himself in proof or in later editions.

For example, in expanding 'Ithaka' almost encyclopedically with detail and references, Joyce decided to have Bloom attend Mrs Emily Sinico's funeral. One can only smile at Joyce's having a character in one novel attend the interment of a character in an entirely different work, wondering, as one might, how on earth, or in the place where the fairies are, Bloom ever came to meet the reclusive and ill-fated Mrs Sinico. In the first edition of *Ulysses* the date of the lovelorn woman's funeral is specified as 10 October 1903. The selfsame episode, however, earlier relates how the late Mrs Emily Sinico was accidentally killed at Sydney Parade railway station on 14 October 1903. In other words, if we are to take *Ulysses* at face value, as Joyce everywhere wishes us to do, Mrs Sinico was buried four days before a train accidentally smashed into her. Is this the great master at his most intensely artistic, or Joyce in a state of carelessness? And if the latter is the true case (as I suspect it is, Clive Hart's warts notwithstanding), how characteristic of the author is this?

In the painful case of Mrs Sinico, the manuscript evidence supports the patently absurd dates cited above, and, unless we appeal to the details of the event as narrated in *Dubliners*, it would not be possible ever to 'correct' the dates, as we cannot determine from elsewhere in the text of *Ulysses* which of the two (death or burial) is wrong. Reference to the original story is not revealing, as no exact date is given for the accident, for the inquest, or for the burial. Only the month is mentioned: on reading in the evening paper an account of the inquest (which took place on the day following the accident), Mr Duffy 'walked along quickly through the November twilight'. In *Ulysses*, not only did the eclectic Emily encounter her death several days after being committed to the grave, she did so a full month earlier than she did in *Dubliners*.

The unspoken requirement that Joyce intended the two accounts to correspond does, I think, compel a sensible and sensitive editor to rewrite 'Ithaca' to the extent of correcting the dates, which are impossible as they stand.

After the first edition had been published, Joyce or an aide noticed the absurd inversion of burial and death and an at least potentially correct date was supplied in a list of errata. The date of the burial was authorially shifted from 10 October to 17 October, restoring a normal temporal sequence to the ritual. Despite this, the modification singularly fails to balance the account with that given in *Dubliners*. There remains the all-important matter of the month in which Mrs Sinico passed away. An editor, accepting that Joyce wished the dates to conform, can and should place himself in the role of co-author, retain the given days as emended and import the month ('November') from *Dubliners*, thereby altering the text of 'Ithaca' in two instances in order to restore the desiderated coherence between the different parts of Joyce's oeuvre.

This gross inattentiveness to detail occurs many times in the text of *Ulysses* as overseen to press by Joyce. For example, in the same paragraph as the offending detail of 10 October, the author, writing in the impersonal and clinical style of an autopsy, records that Bloom, involuntarily, 'compressed between 2 fingers the flesh circumjacent to a cicatrice in the left infracostal region below the diaphragm resulting from a sting inflicted 2 weeks and 3 days previously (23 May 1904) by a bee'.

Alas, 23 May is not 2 weeks and 3 days earlier: it is 3 weeks and 3 days. So Joyce did not notice this particular miscalculation (possibly effected digitally) that spoils the whole point of the sentence. Had it been pointed out to him, as several other mistakes were, he would, I feel sure, have corrected it. Some persons – for example, presidents of American Joyce Societies and ex-trustees of the Joyce Estate – dispute that an editor can validly do so now, with Joyce well and dryly out of earshot. I contend there is no question but that, in a case such as this, the editor is compelled to effect the emendation, as by doing so he produces, however minutely, the greater work of art.

This brings me to Bloom's budget and the degree to which it is imperfect in itself, in its identity with the events narrated, and, on the positive side, to the light it casts on the unnarrated but adumbrated text. Along the way I shall deviate and pursue a few subtexts that one is led into on considering the budget, such as the case of the disappearing bread.

Before descending to the bedrock of detail, I should like to explain that the budget contains in miniature almost the whole of Bloom's *Ulysses*. If one were to reduce Bloom's long and tiring day to a few lines, then the most 'complete' compression possible would be to replicate the budget. Inversely, if all copies of all editions of *Ulysses* were to be destroyed (by a a frustrated Joycean, say, or a relative of the author) and only a single leaf remain, and if one wished to recreate the novel from that leaf alone, then, from a narrative point of view, by far the most useful page to have survived would be that carrying the budget. Expanded and transformed into narrative, the items listed in its two columns

could, in the deft hands of an expert (who would, of course, be excoriated for his intrusion), become the splendid series of social interactions between Bloom and the world that constitute the heart of *Ulysses*.

Let us thus finally, after these various prefatory remarks, see what the budget has to tell us.

Bloom's budget is to found on page 664 of the first edition. It is divided into two columns. The first lists his expenses for the day, totalling £2-2-9 (two pounds, two shillings and nine pence), and the balance remaining to him (the amount he has left in his pocket), namely, £0-16-6.[1] This gives a grand total of £2-19-3. A second column lists the sums of money he has received during the day, alongside the cash in hand with which he began it. This credit side, apparently correctly, totals £2-19-3. The budget is at first glance nicely balanced. A surprise, however, awaits the reader whose curiosity, piqued perhaps by his dismay at Joyce's dreadful dragging across the months of Mrs Sinico's corpse, drives him to check the master's figures. The credit side indeed adds up to £2-19-3, but the debit side does not. There is a variance of eleven pence ('eleven dee', as it was erstwhile succinctly phrased in Dublin), as the total of the given sum amounts to a mere £2-18-4. Something is amiss, but what?

Joyce, or a helper, noticed that something was wrong, and the author subsequently corrected the figures as they stood in early 1922. If we look at the errata list that he prepared, we find that the total is left as is, but the balance is emended to read £0–17–5. In other words, Bloom is given eleven pence more. The text thus corrected is the version that appears in most subsequently printed copies of *Ulysses* prior to the emergence of Gabler's critical edition. Until the good professor re-examined the figures, a generation of critics was perfectly satisfied with them. So what, if anything, was wrong with the author's 'corrected' text?

Despite Joyce's intervention, several problems persisted. Perceiving one of these, Gabler argued that the new budget contradicts the details of the narrated novel. Bloom has, in this official version, £0-17-5 left in his pocket. In other words he must now necessarily have at least two coppers in change. But we know from 'Eumeus' that he spent 'the last of the Mohicans' (*U*:574), as he calls his spare coppers, on Stephen's supper. The budget in this form therefore violates the principle of coherence.

As Gabler observed, the first-edition version resulted from a typographical error made in setting the text from the manuscript. Joyce should therefore, he reasoned, have corrected it by reference to the earlier version rather than by hastily readjusting the figures. In copying the list as written onto the typescript the printer made a single error – the figure given for the cake of chocolate (£0-1-0) was set as £0-0-1, thereby losing 11*d*. Curiously, this 'mistake' was in terms of realism (i.e., the actual cost of chocolate in 1904) a 'correction', and this makes one suspect a conscious rather than an unconscious transformation. Gabler's solution to the problem was simply to replace the penny with the shilling. The 11*d* variance vanishes and Bloom is left with £0-16-6, that is, with a spare tanner but with no coppers.

But can we be satisfied and let the matter rest here? As said, a penny is historically a more realistic sum for a piece of 1904 chocolate than an outrageous shilling, and, in looking over the first edition list, Joyce, one would assume, on being told that the total was wrong, would have checked the individual items for accuracy before changing the balance. If he did, he chose to leave undisturbed the penny cited for the chocolate (not otherwise priced in the novel). While this still leaves us with a textual contradiction, Joyce having forgotten for a moment about Bloom's Mohicans, it may represent a revision on Joyce's part. If so, no version of the budget – Joyce's or Gabler's – fully satisfies.

The root of the problem is at once both larger and smaller. The figures in both cases have to be wrong – there are elements omitted; for example, not all of Bloom's journeys by train or tram are included. Furthermore, none of the

[1] The now-obsolete, but rather beautiful and (to its possessors) deeply satisfying old coinage of the Realm might cause some confusion. It goes like this. The pound (or 'sovereign') comprised twenty shillings, and each shilling comprised twelve pennies (pence). These basic units were denoted by the symbols £. *s*. and *d*. respectively. These in turn are abbreviations for the Latin terms libra (a pound), solidus (a shilling), and denarius (a penny), via the Italian lire, soldi, and denari. If farthings (see below) were expressed, the letter q (quadrant) was employed. The symbols were introduced by the Lombard merchants, from whom also we derive Cr. (creditor), Dr. (debtor), bankrupt, and do or ditto. The penny was (in value) subdivided into two half-pennies ('happence'), which in turn were each further subdivided into farthings, the smallest coin (and practically useless. I do recall, however, spending a farthing as a child on the purchase of three 'Nancy balls' [aniseed balls: a kind of cheap hard-boiled sweet]). Three pennies were equivalent to another coin: the 'thruppeny' bit; and six pennies to the 'sixpenny bit' or 'tanner'. A shilling was colloquially known as a 'bob'. The florin coin was equivalent to two shillings. A further denomination – of some considerable weight fiscally speaking – was the 'half-crown' or 'half-a-crown'. This was equivalent to two shillings and sixpence, a royal sum. Finally, professionals such as doctors and solicitors who liked to squeeze the poor came up (in their bills) with the aristocratic guinea, or one pound and one shilling (i.e. twenty-one shillings). Thus, beginning with the measly farthing, the coinage circulating in Chapelizod and the rest of the Empire in the year 1904 (and for many a long day after that) was (in symbolic form):- ¼*d*. | ½ *d*. | 1*d*. | 3*d*. | 6*d*. | 1/- | 2/- | 2/6 | and £1. This diversity permitted wide permutation and, accordingly, for penny-pinchers such as shopkeepers, the ability closely to shave margins.

printed or published lists (prior to the Reader's Edition) precisely reflect, as indeed they are intended to, the sequence of Bloom's expenditures as narrated. It follows that the scrupulous would-be editor has to reject all previous versions, including Gabler's, and begin afresh, reading through the book to see how far Joyce's account strays from the 'real' budget and whether or not, in adjusting the figures to conform with the given facts, the resulting overview balances.

CREDIT

Looking first at the credit side of affairs, a mere three items, we can quickly isolate a major problem.

The first item, the cash in hand, is listed as £0–4–9 and cannot be disputed. It is not mentioned elsewhere in *Ulysses* and must be taken at face value. All that we can say is that, on stepping out, Bloom probably assumed that he had only 3/9, as it is only in the last minutes of his day that he discovers the extra bob in his waistcoat pocket.

The second item is likewise unique to the budget and incontestable. We simply have to accept Joyce's word that Bloom received £1–7–6 in commission outstanding from the *Freeman's Journal*.

The final item, the loan received from Stephen, is incorrect. The text is very clear that Bloom 'borrowed' precisely £1–6–11 from Stephen. The budget needs to be amended accordingly. That Joyce was muddled as to the amount is evident from the various different figures he supplied: £1–11–0 in the typescript, £1–7–0 on the proofs, and, bizarrely, £1-6-0 in the 1926 edition.

DEBIT

The debit side opens with Bloom's early-morning purchase of a pork kidney from Dlugacz's butcher's shop *(U:57)*. This occurs in 'Calypso', where the outlay is confirmed at thruppence, adding the detail that Bloom pays the bill with three coins (coppers).

The second item listed – the newspaper for a penny – refers to a purchase that lies outside the text, falling between 'Calypso' and 'Lotus Eaters'. All that is told us is Bloom's intention to check the paper for details of the funeral and, later, the fact that he is in possession of a copy. Incidentally, the price of the newspaper at one penny is historically accurate.

Not included in the budget, as not paid, is Bloom's purchase in Sweny's the chemists in Lincoln Place *(U:81)* of bath lotion for Molly, costing two shillings and nine pence, and a bar of lemon soap, costing four pence. The budget nevertheless provides us with an explanation as to why Bloom did not cough up there and then. He had insufficient cash on him – only four shillings and five pence (and presumably believed he had even less, viz. three shillings and five pence [v.s.]). Paying the chemist would have left him short for the much-desiderated bath, the next item on his agenda.

This experience of a bath and gratification, costing a hefty one shilling and sixpence, also falls outside the written page. When we leave Bloom in 'Lotus Eaters', he is headed for the mosque of the baths but we do not see him arrive there. We learn later, in 'Nausicaa', that he had indeed visited the premises as, in reflecting to himself, he thinks 'Damned glad I didn't do it [masturbate] in the bath this morning over her silly I will punish you letter.'

At this point, therefore, having paid for the bath, Bloom has two shillings and eleven pence remaining to him.

The next item, a penny for a tram journey, is nowhere narrated but can be inferred. After the bath, Bloom has somehow to get down to 9 Newbridge Avenue in Sandymount to join the funeral cortège. Time is short and the logical way for him to get there is to take a tram. The cost specified in the budget is historically accurate.

The sixth item (and the fifth to relate to an event occurring outside the written text) involves Bloom donating five shillings *in memoriam* Patrick Dignam. While not described, this donation is amply confirmed by the text. We are informed in 'Hades' that Cunningham, who travelled in the coach with Bloom, Dedalus senior, and Power, is arranging for a 'whip up for the youngsters'. He is soliciting contributions towards a kind of emergency fund to help little Paddy's widow out, something in the region of a few bob a skull. 'Just to keep them going', Lambert remarks to Dedalus, 'till the insurance muddle is cleared up' *(U:99)*. Nowhere in 'Hades' is Bloom described as being approached, but we learn later in the text, in 'Wandering Rocks' *(U:235)*, that he put his name down for five bob. Cunningham and Power seem to spend the immediate post-'Hades' hours actively collecting and seeking to augment the money. Cunningham is still looking for donors when we meet them again in 'Wandering Rocks'. Reading through a list of subscribers, John Wyse Nolan is taken aback at Bloom's generosity. Cunningham confirms it and adds that Bloom went further – he put down the five shillings too. Power, standing beside them, embellishes the account – Bloom did so 'without a second word either'. We can only interpret these remarks to mean that both Cunningham and Power were physically present when Bloom handed over the cash.

A good question is when and how Bloom put the money down. It cannot have been while at Glasnevin, as might seem plausible, as he didn't have enough cash on him to cover it (he is the proud possessor of two shilling and ten pence ['two and ten']). This consideration helps to explain why we find, mysteriously, a group from 'Hades' hanging around the offices of the *Freeman's Journal* immediately after the funeral, instead of their having proceeded directly to a pub for a drink (their intention). At least two coaches must have returned to the city centre, returning Bloom, Dedalus, Cunningham, Power, Lambert and Hynes to O'Connell Street. These would have proceeded directly to the adjacent offices of the *Freeman's Journal*, though for different reasons. Bloom, Power and Cunningham would have gone there primarily for Bloom to collect what was owing to him in commission, thereby allowing him to hand over the five shillings, with Power witness to the transaction. Cunningham and Power would then have left together, still bent on Dignam's affairs, while Bloom remained behind to attend to his own. Lambert and Dedalus would have gone on in to ask the editor to join them for the premeditated drink, and Hynes would have gone in to file his report of the funeral. This is the position when the episode opens, with Power and Cunningham already out of the picture.

All published versions except one concur in the important matter of the five shillings. It was not included (perhaps as it is not narrated) in the earliest extant version of the budget (the base-text of the second typescript) and it does not feature in subsequent galleys before its intercalation at third-proof stage, when Joyce evidently recalled it.

On leaving the newspaper offices (taking into account his generosity to the widow and the one pound, seven shillings and sixpence he picked up), Bloom has now one pound, five shillings and four pence in his pocket.

The sixth item, two Banbury cakes for a penny, brings us to the immediate post-'Aeolus' episode, 'Lestrygonians', which, at an early point, describes Bloom's second act of generosity. Watching the gulls as they wheel over the river while he crosses O'Connell Bridge, he is moved to compassion for their pitiable existence, constantly in search of a scrap to eat. Accordingly, he procures some cakes from a street vendor, crumbles them up and tosses the fragments down to the gulls. The cost to Bloom of this unforeseen budget-listed expense is clearly stated in the text (*U*:146) as one penny.

Again, all versions agree with this. The grand (and diminishing) total of £1-5-3 thus remains to Bloom.

The partaking of lunch forms a large chunk of the food-oriented 'Lestrygonians' episode and the author vividly details the transaction. Bloom is charged seven pence (*U*:164) for his glass of burgundy and cheese sandwich and, it seems, pays an exact amount requiring no change, probably one sixpence and one copper.

All editions agree with this sum. The post-prandial Bloom has now £1-4-8 remaining.

Bloom incurs no new expenses in 'Scylla and Charybdis'. This is logical enough, given the fact that the episode originally formed part of the Stephen-centered, pre-Bloom chapters of what is now Part I. When this – the library episode – was first written, Bloom as a character had not as yet been conceived of. His inclusion was by way of subsequent adaptive modification of the narrative and serves as a bridge between episodes. At the same time, we can appreciate Joyce's skill in drafting the earlier episodes so as to allow Bloom to end up in the library with a plausible reason for being there. He has slipped into the building to avoid bumping into Boylan, who he sees walking jauntily up the road. Other than this, he wants to examine the backsides of some statues in the library to see if and how the anal orifice is represented and, third, in the way of business, he wants to look up one of the provincial papers.

'Wandering Rocks' is something of a benign cuckoo in Joyce's nest, coming as it did only after the rest of the book had been conceptualized and as such not at all fitting in with the Homeric prototype. Of the 'Rocks' only a small section, the central tableau, is dedicated to Bloom. We find him dark-backed in Merchant's Arch, lost in the perusal of second-hand books. It is clear from his remark on being handed *Tales of the Ghetto* by the bookseller ('That I had, he said, pushing it by': *U*:225) that he has been there before and, by inference, that the books are not for sale but for rent (he had had the *Tales* out before). *Fair Tyrants*, another potential, he also remembers having had out. It soon becomes apparent that Bloom is looking for a book not for himself but for Molly, and he finds one – *Sweets of Sin* – that is suitably lush for her taste in literature. Though disturbed by some passages in it, putting him too much in mind of his wife's four o'clock assignation with Boylan, he decides to take it. We do not at this point in the novel witness the cash transaction; but we learn later, from the budget, how much he pays the bookseller.

The business with the purveyor of dirty books (in years yet to come the odd tattered copy of the Reader's Edition of *Ulysses* might be stored under his counter) furnishes us with the next item in the budget, which specifies the rent renewal as one shilling. While it is clear that Bloom is a regular customer and that the books are rented, the amount charged surprises. It cannot surely be that the going rate is a shilling a book. Who would pay that kind of money? We must sup-

pose that Bloom is paying not for the single volume he had borrowed but rather a general charge of some kind, perhaps a monthly fee.

Whatever the case is, it is now seventeen minutes after three o'clock and Bloom has exactly one pound, three shillings and eight pence remaining to him.

The next item – a tuppenny packet of notepaper and envelopes – derives from 'Sirens', just before Bloom writes to Martha over his dinner. The purchase is described allusively but definitively (*U:252*). Bloom pays for the writing materials, clearly handing over a sixpence. The shop-girl gives him four pence in change. This tiny detail might seem to contradict the perfect realism of the novel, for Bloom has two coppers in his pocket, cumbersome coins he would normally have used in payment. Looked at another way, Joyce perhaps intends the attentive (obsessive?) reader to read into Bloom's fumbling his extreme agitation at this juncture (he is avoiding bumping into Blazes Boylan).[2]

Returning to the budget, all editions and versions accept the cost of the writing materials. Bloom now has one pound, three shillings and sixpence in his pocket.

Bloom's dinner of liver and bacon washed down with cider is also described in 'Sirens'. The cost is specified (*U:270*) as one shilling and nine pence. The amount of Bloom's tip is more ambiguous. The text reads:

'Must go, prince Bloom told Richie prince. No, Richie said. Yes, must. Got money somewhere. He's on for a razzle backache spree. Much? He seehears lipspeech. One and nine. Penny for yourself. Here. Give him twopence tip.'

This is ambiguous indeed. It must mean that Bloom tipped the waiter Pat twice: first, a penny; then, tuppence, as we learn later that Pat ended up with the aggregate thruppence (and we recall that Bloom had at least three coppers on him, following the purchase of the writing materials). In compiling the budget Joyce quotes the composite – meal plus tip(s)– price as two shillings.

Leaving the Ormond Hotel behind him (and us), Bloom's lump has now been degraded to one pound, one shilling and sixpence.

Whilst writing to Martha, Bloom decides to send her a postal-order for two shillings and sixpence as a 'little present'. Accordingly, after leaving the Ormond he heads for the nearby postoffice. While his business there once again occurs outside the pages of the novel, the budget confirms that he spent a total of two and eight, which sum neatly incorporates both a penny for the poundage on the postal-order and a penny for a stamp for the letter.

Again, no editions or versions disagree on this sum and, tracking Bloom's expenses, we note that he is now down to less than a quid: i.e. eighteen shillings and ten pence.

We learn from Bloom's musings in 'Sirens' that he has arranged to meet with Martin Cunningham in order to visit Paddy Dignam's widow. 'Barney Kiernan's I promised to meet them. Dislike that job. House of mourning' (*U:268*). He keeps his appointment (in the course of which he is abused and assaulted) and duly visits the widow. Afterwards he strolls down the strand, encounters the girls, masturbates for all he is worth, and all but falls asleep in post-ejaculatory languor on the rocks. The extended period between his exiting the Ormond Hotel and his seaside snooze does not involve him in any new expense. He buys nothing in the pub (though he cadges a cigar) and he gets a free ride from Cunningham down to Sandymount.

At the close of 'Nausicaa', a sleepy Bloom is unsure whether or not he should head on home. It is pushing on for nine o'clock and too late to visit the theatre; but, understandably, he doesn't relish the prospect of facing Molly. He decides instead to go to the maternity hospital in Holles Street to check on Mina Purefoy. Mina – as he has heard earlier in the novel from Mrs Breen – is some three days overdue and having a difficult time of it. To get back to the city he needs to take a tram. This tram ride takes place outside the pages of *Ulysses*, but it is not unnoticed by the narrator of 'Ithaca' who faithfully registers the journey and its cost – one penny – in the budget. This entry, which is not disputed in any version, reduces Bloom's lot to eighteen shillings and nine pence.

Once the students, medicos, and Bloom leave the hospital at the close of 'Oxen', they proceed, late as it is, to Burke's, a nearby public house. Stephen, who now seems rather carefree with his rhinos, pays for the rounds. The episode ends

[2] Two pence, incidentally, provides a minor subtext all to herself. It is the sum that the milk-woman is left short of, although Stephen has that sum in his pocket at the time she is being paid and could easily have given it to her. It is the sum that Simon Dedalus gives Dilly for a glass of milk and the amount that Stephen (mistaking half-crowns for pennies) intended to give Corley (in the event he gives him one half-crown thereby balancing Bloom's gift to Martha). Finally, tuppences abounding, the four coppers which Bloom gives to the keeper in 'Eumeus' for the coffee and bun comprise two pennies deriving from Stephen's pocket (picked up by Bloom) and two of his own.

with the disgorging of the students into the street and their heading off in different directions: Stephen and Lynch, en route to the Kips, to the railway station. Bloom, paternally worried about Stephen, follows them.

There ensues a significant gap in the action: the ambush by the suitors. This may have been included in a lost early draft of *Ulysses* that Joyce subsequently decided to omit from the text. In brief, Stephen encounters Mulligan and Haines at Westland Row railway station. An altercation follows, after which the duo give Stephen the slip and return to the tower in Sandycove. The scene is witnessed by Bloom, as we can establish from his musings in 'Eumeus'. Stephen and Lynch meanwhile hop on a train. Bloom follows, though he temporarily loses sight of them.

Bloom resurfaces next in 'Circe'. He thinks:

'Wild goose chase this. Disorderly houses. Lord knows where they are gone. Drunks cover distance doublequick. Nice mix-up. Scene at Westland Row. Then jump in first class with third ticket. Then too far. Train with engine behind. Might have taken me to Malahide or a siding for the night or collision. Second drink does it. Once is a dose. What am I following him for?'

Irrespective of how Bloom lost sight of Stephen, the logic of the book and the text itself require a new expense for Bloom: the third-class train-ticket. This item appears only in the Picador Reader's Edition and it necessarily depletes Bloom's total by a further penny, leaving him with eighteen shillings and eight pence.

'Circe' seems to have caused Joyce enormous problems as regards Bloom's financial manoeuvers. In the earliest extant budget, the typescript, no entries whatever appear between the post-'Nausicaa' tram fare and the coffee-and-bun from 'Eumeus'. Noticing this oversight, and possibly consulting only the first few pages of an early draft of 'Circe', he added in the margin four new elements:

1 Pig's Crubeen	0. 0. 4
1 Sheep's Trotter	0. 0. 3
1 Cake Fry's Plain Chocolate	0. 1. 0
1 Square Soda Bread	0. 0. 4

Reading the final (1922) text, we note that Bloom enters the chapter already clutching the bread and the chocolate – his first act is to cram the eatables into a side pocket – but he has not yet bought the crubeen and trotter. Accordingly, these items should correctly precede the listing of the crubeen and trotter in the budget (this is done for the first time in the Reader's Edition). In an early draft, Bloom enters the chapter carrying all four items: 'a pig's crubeen and a sheep's trotter … two slices of quartern loaf [had our hero already eaten some?] and a tablet of Fry's chocolate' (Buffalo MS. V.A.19). As well as listing the comestibles as repeated in the TS addition, this very nearly matches the same sequence.

What is not at all clear is why Bloom purchases these commodities in the first place: for himself; for Molly; for Stephen? In any event, he dumps the crubeen and trotter for a stray dog to devour and he shares the chocolate with Lynch and the tarts. What happens to the bread is something of a mystery; no account of its fate is given anywhere in the text. One possible solution is that, in the interval between Bloom's disappearing into the basement of 7 Eccles Street and his reappearance at the front door, he took it out of his pocket and deposited it, appropriately enough, in the kitchen. It is nevertheless even more possible that Joyce simply forgot about it.

This accounts for the different destinies of the four items, though not for their costs. Of the four, only the trotter is priced in 'Circe' and we must look to the budget for the details regarding the others. Of these, the pig's foot at four pence and the bread at ditto are nowhere disputed. The chocolate, on the other hand – as we have earlier said – depending on one's interpretation of the documents is either one shilling or one penny. The penny is historically the more accurate, and the tablet may well have been obtained at one of the chocolate-vending machines that were common in railway stations at the time.

The neatness of identifications collapses somewhat in 'Circe', over and above the issue of the chocolate. The spectre of Rudolph Bloom, on meeting his son Leopold, berates him for wasting another half-crown. The first half-crown is presumably a reference to the postal-order sent to Martha (ghosts tend to know about such things) and so the second must refer to the parcels carried by Bloom. Rudolph accuses his son of wasting time and money on 'drunken goys'.

This is perhaps an indication that Bloom has bought the food for Stephen's benefit. If he had bought it for himself or for Molly, Rudolph could hardly call it a waste of money. Why he specifies a half-crown is obscure, as in no version does the total remotely amount to this. It is possible that in the earlier draft (from which the half-crown figure derives) Joyce had intended Bloom to spend this amount; if so, he abandoned the plan, and we must now consider Rudolph's remark as either hyperbolic or a wild guess. Sinisterly, however, and giving grounds for the positing of a lost working budget, a second reference to the troubling half-crown mentioned by Rudolph appears later in 'Circe' (*U*:424) when Bloom discards the trotter: 'Sizeable for thruppence. But then I have it in my left hand. Calls for more effort. Why? Smaller from want of use. O, let it slide. Two and six.' At this point we encounter a serious oversight in the budget. No entry is made of Bloom's expenditure in Mrs Cohen's, although (significantly) his receiving the 'loan' from Stephen (which also occurred inside the brothel) is included. Previous commentators have opined (feebly in my view) that this may be because the budget is meant to reflect Bloom's pillow account of his travels to Molly. This simply cannot be the case as the postal-order to Martha is included in the budget, and we know for a fact (*U*:644) that Bloom did not mention this, for understandable reasons, to his wife. A more likely explanation (which is confirmed in part by the many attempts he made to complete and correct the budget) is that when Joyce came to compile it, only a few weeks prior to publication, he was intensely busy and found it difficult to determine from the text precisely whose money had been used to pay Mrs Cohen. This is not surprising if we note, for example, how, after ten years of intensive study of the text, the American scholar John Kidd continues to believe that Stephen had paid for Bloom. This is not so.

Near the end of the episode, Bella Cohen demands payment for the girls at the rate of ten shillings per girl. Stephen obliges by giving her a pound note; then, when Lynch asks Stephen to pay for him, a further half-sovereign; then, when Bella falsely insists the amount is not enough for all three girls, an extra two crowns, making a grand total of two pounds. Although Stephen is drunk and unaware of the innocent little deception, Bloom spots what is going on. Extracting a half-sovereign from his own pocket, Bloom approaches the table where Bella had been counting and distributing the money, picks up the pound note (with the intention of returning it to Stephen) and replaces it with his own half-sovereign coin, remarking as he does so: 'Allow me ... Three times ten. We're square.' Bloom has thus paid ten shillings for 'his' girl, as has Stephen. Lynch pays nothing, sponging the money from Stephen. Bad value, all in all.

Bella accepts Bloom's intervention with relatively good humour and Bloom approaches Stephen to return the retrieved pound note to him. Stephen responds by pulling a handful of coins from his pocket, obviously flustered as he cannot understand why the pound note should be given to him. Bloom, observing the boy's inebriated condition and fearful of the young man being further gypped, offers to mind his money for him. Stephen carelessly hands his loose change over to his new banker, and Bloom counts it: 'One, seven, eleven, and five. Six. Eleven. ... one pound six and eleven ... One pound seven, say.'

As the episode draws to a close, Bloom pays over a further shilling to cover the cost of the lampshade broken by Stephen, elevating his total payment to Mrs Cohen to eleven shillings. Allowing for these items, Bloom's cash in pocket comprises one pound, six shillings and eleven pence belonging to Stephen and six shillings and eight pence belonging to him (all he has left). We note from this that he must have to hand at least four coppers, two from Stephen's money and two from his own.

The final expense Bloom incurs is in 'Eumeus' (*U*:573-74), where he pays four pence for Stephen's coffee and bun. The text is specific here and requires that Bloom has only four coppers left, the rest being coins of a larger denomination.

All versions agree on the price of the bun/coffee, but none, apart from the Reader's Edition, allow for Bloom to have four (and only four) coppers in his possession. On the surface, the text of the Gabler edition appears to grant Bloom four coppers. This illusion, however, comes about only because Gabler's budget itself contains its own quantum of 'mistakes', for example the train fare is omitted (deduct one penny from Bloom's total) and the money received from Stephen is given incorrectly as £1-7-0 (deduct another penny)[3]. Note that the two mistakes are subtractive and do not cancel each other out.

When, as narrated, Stephen's loan is refunded, Bloom hands him one pound and seven shillings (the rounded-off figure) and not one pound, six shillings and eleven pence (the actual amount 'borrowed'). It is irrelevant whether this is

[3] In a textual note Gabler points this out and uses it to argue for the retention of the unhistorical price of one shilling for the chocolate. Unfortunately his logic is not comprehensive.

by accident or by design, as Bloom has no choice in the matter. He has no coppers, and neither has Stephen.

Bloom thus ends the day with six shillings and thruppence to his credit, an increment of one shilling and sixpence on the four shillings and nine pence with which he started. This represents an increase of eighteen pence, exactly one penny for each episode of *Ulysses*.

This amount and the carefully established figures that precede it as outlined above appear only in one edition, the Reader's Edition of *Ulysses*. Only in this editorially reconstructed account do the three books balance – Bloom's, the narrator's, and James Joyce's. Four other versions, each incorrect and misleading in a different way, can be found in the alternative editions that are currently available in the bookshops.

What is remarkable is that Joyce wrote *Ulysses* in a manner sufficiently controlled so to permit an attentive, numerate, and long-suffering editor, armed with the details as set out in the various episodes and with various proto-documents, to reconstruct an accurate budget, a budget that is historically realistic and that accounts for every item narrated either directly or indirectly in the novel.

For the reader, the corrected budget allows a one-to-one correspondence between the events as narrated and the specifics of the two columns. *Ulysses*, as I remarked at the beginning of this essay, could at least in outline be recreated from this one single page, but only if it is both comprehensive and accurate. The closure that a corrected budget imparts to the novel – rather like a terrific funeral – more than justifies, in my opinion, the relatively minor editorial emendations required to bring the total into balance.

A corrected budget presents a complete, and not a distorted and truncated view of *Ulysses*. It confirms what we (and Joyce) had hoped of his book: that the accounts he has given us of Bloom's day – the narrative itself and the synoptic overview of it – match and are internally coherent. Balancing the budget conceptually balances the books.

That it required a textual editor – criminally radical in the view of the establishment – to clarify the issue is neither here nor there. The figures are compelled if we wish (as we must) to represent Joyce's premeditated, often stated, yet unachieved intention for his masterpiece to be complete in itself. To reject this and like editorial interventions (as repeated acts of rape, as it were, on the body of the pristine text) renders impossible any serious hope of critically and intelligently establishing a text, and abandons texts (which belong to us communally) to the tyranny of historical accident and heirs, and condemns great writers to the prison of their own time and place, a state of affairs that they all, and particularly Mr Joyce, sought so strenuously to escape.

Writer, Editor and Joyce scholar
('On Editing *Ulysses*', a colloquy given at the James Joyce Centre, 10 February 1999; revised 15 September 2009)

implication

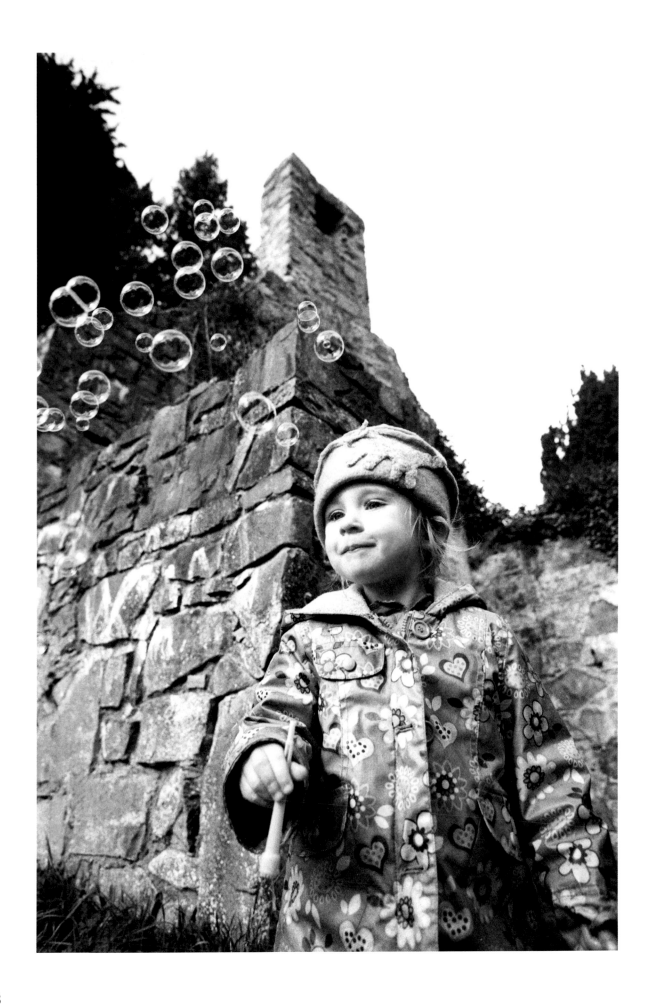

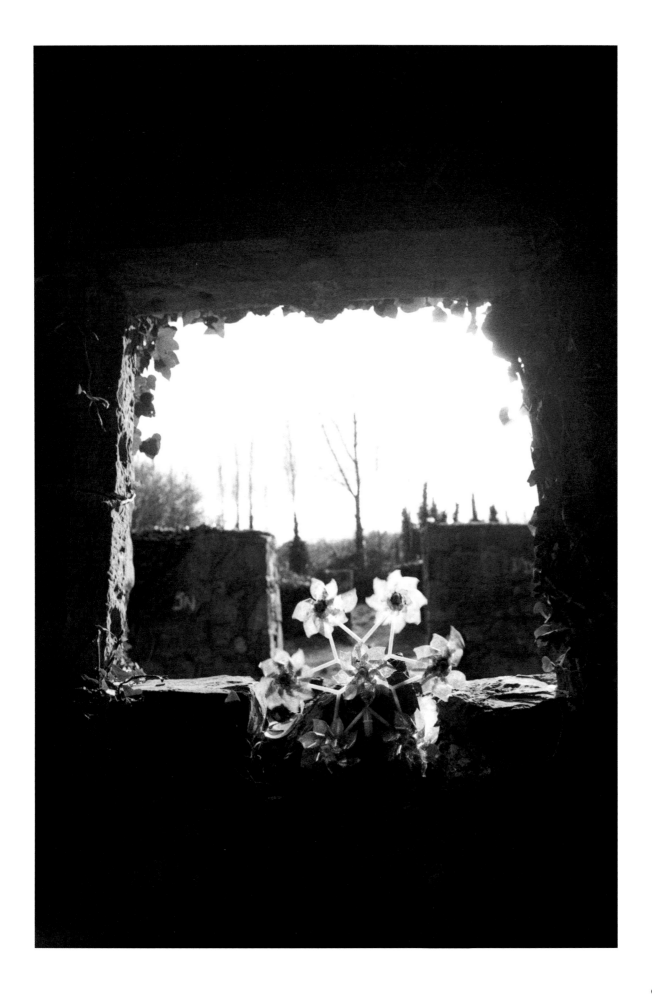

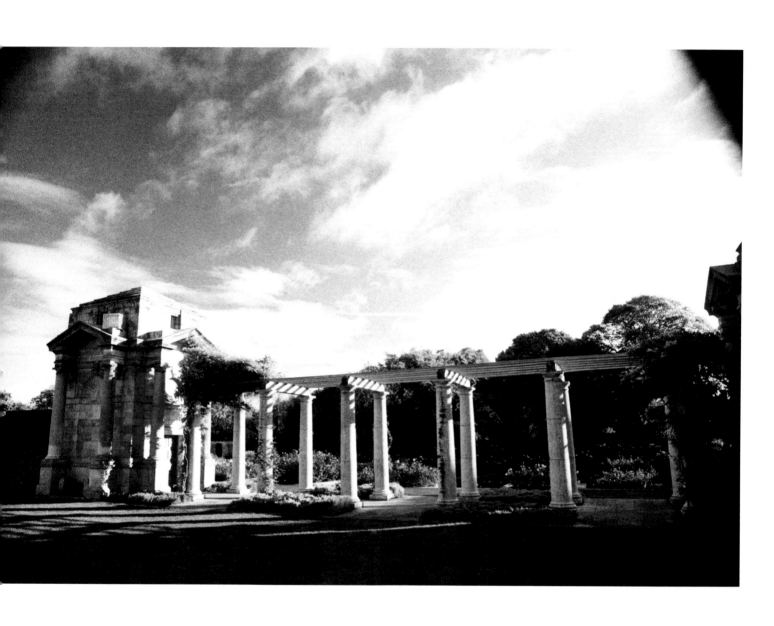

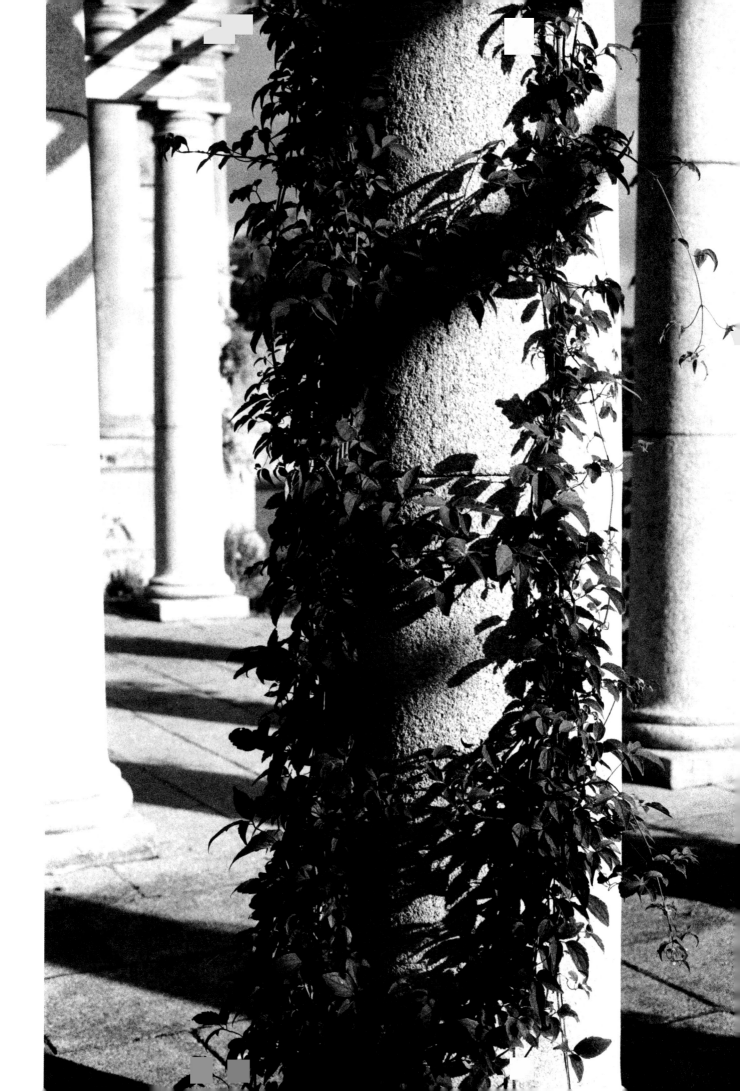

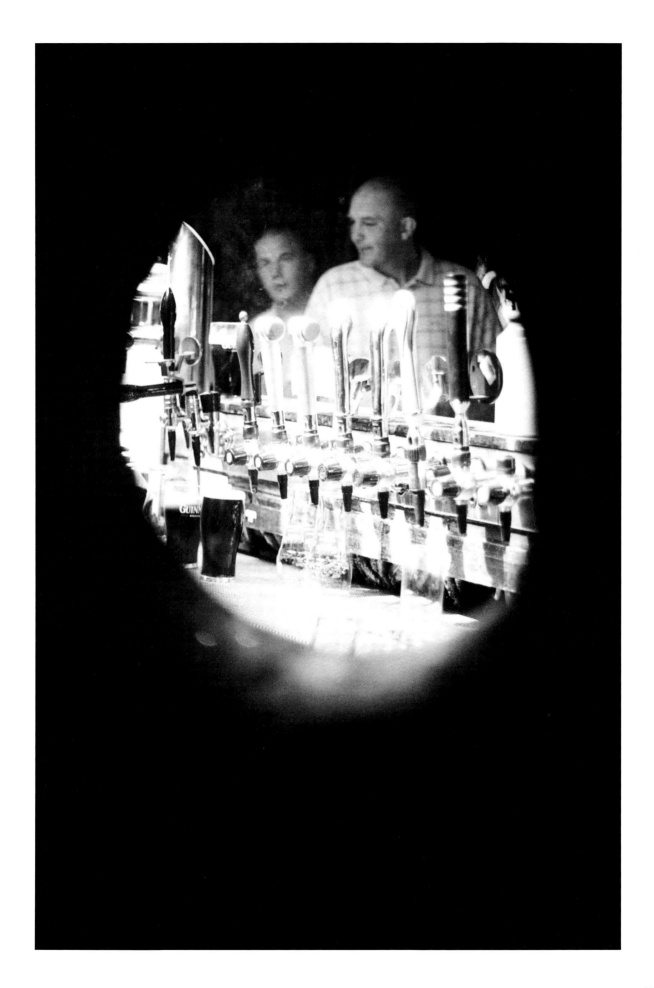

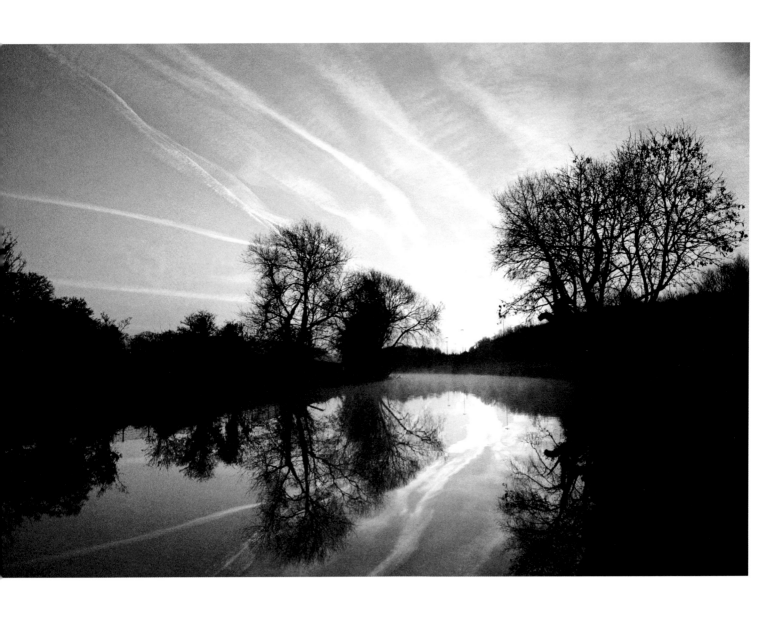

THOMAS MACGIOLLA

Chapelizod is translated into Irish as Séipéal Iosáid (Isod, Iseult). Since Isolde was a pre-Christian princess I believe the name was given to the village by the Normans in the twelfth century as Chapelle Isolde. They knew the story of Tristan and Isolde as it was widely known and repeated and used all over Europe. When they were building the defensive wall around the new Dublin city, the first main defensive tower they built to meet the attacking Vikings coming up the river Liffey at full tide was called Isolde's tower.

I think that anyone who speaks or writes about the village must speak or write about Isolde. Yet today no one speaks about her and there is not a road or a bridge or a house or any part of Chapelizod called after her. She is dismissed as a mythical figure as if that was something to be derided.

But our whole culture is built on our great mythical heroes, their strength, power, speed and bravery, their pride, their honour and their deception, their love and their hate and above all their great passion. It's still there today in our music, our song, our dance and our games.

In literature no greater passion has been expressed than that between Isolde and Tristan. They inspired poems, plays and novels but also music such as Wagner's greatest opera *Tristan and Isolde,* which he described as 'The simplest of music conceptions but full blooded' and Liszt said, 'It is something to weep over and flare up in enthusiasm. What ravishing magic! What an incredible wealth of beauty.' Wagner's opera has also been described as 'a poem for poets, a score for musicians' (these quotations are from *A day with Wagner* by M. Byron).

The reason that I emphasize the power, influence and passion of Isolde is that I assumed that James Joyce, who spent so much of his time following the footsteps and stories of his father in Chapelizod, who worked in 'the still that was a mill', would himself be influenced by her and would speak and write about her.

However, I couldn't find her in the works which I was able to read. He created Anna Livia from 'abha na life' and referred to her frequently. Many years ago I read that Joyce saw Anna Livia's head in Chapelizod, with her body stretched down along the quays through the heart of Dublin City and her legs stretched out through the North Wall and South Wall, open to welcome the incoming sea! But I don't know if this was something that Joyce said or if it was one of the thousands of interpretations or analysts who suggested the idea.

I had read Joyce's *Dubliners* in my late teens and did not enjoy or even see the point in some of the stories. I wasn't surprised when I heard it took years for him to get them published. Later when I got a job in the ESB I was told that Joyce had written a book called *Ulysses* that was banned by the censorship committee. I had learned a lot of Roman history and was interested in Ulysses and wondered why a book about an ancient heroic figure would be banned. I soon discovered that a small bookshop in Lower Baggot Street called the 'Brown Jacket' could get this book if I could be trusted. I was already a customer of this shop, where I bought my daily paper, cigarettes and some small pamphlets. One day when I was alone in the shop I asked the owner if he could procure *Ulysses* by James Joyce for me and he just said 'Maybe, but it is very expensive.' I asked 'how much?' and he said, 'could be over ten pound'. This was a huge sum at

the time and I was on a good wage of £5.15, but I said, 'I will talk to you again in a month's time'. Which I did, and got the book later. In the meantime I found that while it was banned in the US, it was not banned by the censorship board in Ireland. But it was very publicly banned by John McQuaid, the Archbishop of Dublin, who warned every bookshop that if they sold it he would have them shut down. Which he could have done at the time. When I discovered that *Ulysses* was not about Rome but Dublin I skipped through as much as I could. I found no trace of Isolde or even Anna Livia. I was, however, fascinated by Bloom's travels through the city which, within the canals and in East Wall and the Docklands, had not changed a bit from the twenties to the fifties, when I was reading it.

Forty years of an exceptional busy and traumatic life passed before I purchased his other great work, *Finnegans Wake*. As Lord Mayor of Dublin 1993-4 I visited Kyoto, Japan, where I was told of their love of Irish literature. They told me about Lafcadio Hearn and gave me his biography, they showed me a huge statue of Swift's Gulliver in a children's park and when I was leaving they presented me with a copy of *Finnegans Wake* in two volumes in Japanese. At this I could only stand with my mouth open and utter 'Thanks.' The Japanese could read *Finnegans Wake* and translate it into Japanese! And I hadn't even bought it because everyone told me no-one could read it!

Of course when I got home I purchased *Finnegans Wake* at once. When I opened it there was Sir Tristan on the very first page and reading further down I found one word covered two lines and contained one hundred letters. As I went on it became more and more difficult to read, just as everyone had told me. I therefore skimmed through page after page and while I found one or two further references to Tristan there was no sign of Isolda, Iseult, Isolde, Izod, Isoid or even Izard, as the Duke of Ormond spelt the name of the Village Chappelle Izard. I cannot definitely say there was no reference to her as I have not read the book page by page. All I can say is that I did not find any reference to her. This was a great disappointment to me.

But while I could find no trace of Isolde I found a whole chapter on Anna Livia Plurabelle. He writes: 'At Iron Bridge she met her tide. Attabom, Attabom, Attabombombboom.'

Here the Bomb Bomb Boom seems to mean war, or at least a battle. When Anna Livia met the tide at Iron Bridge she fought it off and pushed it back out to sea. There was no welcome there, which seems to contradict the earlier suggestion that she was welcoming in the sea. However, Joyce could be showing the contradiction going through Anna Livia's head just like Molly Bloom's. Her head says to the sea, get out of my territory. But when the legs get down to Ringsend they forget about the head and open up to welcome in the powerful sea – Joyce always leaves you wondering. He loves contradictions, he loves mystery and he loves wonder.

Things rested, as our great story-tellers used to say. In 2007 I was introduced to a Japanese lady who is married to an Irishman and now lived in Chapelizod. She told me she has a Master's degree from Baiko Gakuin University in Shimonoseki City Japan. She studied Irish literature and especially she was influenced by James Joyce. This was a great surprise and joy to me. She told me that her professor Shigehisa Yoshizu was coming to Ireland in the summer with a group of thirty students and others interested in Irish literature, and they would pay a special visit to Chapelizod. I was delighted to help in any way I could to welcome them. Professor Yoshizu was well known in UCD where he was a visiting research professor in 1987 and 1988. Eventually we all met in the Mullingar House at 4 pm on 19 September 2007.

The speakers at this meeting were Professor Yoshizu and Dr Luca Crispi of University College Dublin, a world-renowned expert on Joyce his life and his work. Professor Yoshizu spoke of his love of Irish literature and of the Irish people and in particular of James Joyce. He was now looking forward to this visit to Chapelizod, the centre of so much of the writings of Joyce and in particular his great work *Finnegans Wake*. He was followed by Dr Crispi.

Dr Crispi spoke to us without notes. He spoke in a casual, chatty way just telling us a story. The story was what *Finnegans Wake* was all about and how and why Joyce wrote it. I was fascinated, amazed and overjoyed to hear that this work was all about the great love affair of Tristan and Isolde and the triad of Tristan, Isolde and King Mark.

I was delighted that James Joyce had not let me down. Myth or no myth, Tristan, Isolde and King Mark existed in a real and memorable way and are still probably the most widely known people in all of Europe and now in Japan. Of course I am now trying to read every word written so painfully by James Joyce in *Finnegans Wake*. It took him seventeen years to write it. Will I ever finish reading it!?

I now look forward with great interest to reading Motoko Fujita's vision of James Joyce's vision of Chappelle Isoid.

Former Lord Mayor of Dublin, local historian'

RAPHY DOYLE

Stones move us to reflect on what may have gone before. William Dobson's bridge over Anna Livia Plurabelle at Chapelizod connects us with our Scandinavian heritage. The seven miles of the Phoenix Park's wall from the Earl of Ormond's work to that of Sir William Temple was built to contain and enclose the Lord Deputy's deer park. But now the nine gates admit the public, both the 'plebs' and the 'quality', to tree-lined walks, great houses, Zoological Gardens and places of natural beauty. Fun-seekers, runners, walkers, watchers, players, killers and criminals; all have their places alongside Governor Generals, presidents, Pope John Paul, Count John McCormack, park-rangers and other 'Invincibles'. The Wellington Memorial, once the world's tallest obelisk, competes with the distant Spire to dominate Dublin's skyline.

Today Mount Sackville Convent School educates and supports where once the sisters of St Joseph of Cluny toiled with the poor and the infirm. Sister Gerard Deegan's hands lie there at peace after courageously caring for her dead sister's children, saving them and empowering them for the future. Down the hill, Glenmaroon, where similar care was bestowed close to the old toll road to the west, lies empty by its Riverrun. The low-lying chapel of the fourteenth century has few in attendance, its gravestones witness to its former storied status. The water tumbles noisily over the weir to where it powered 'the still that was a mill', near where the wordsmith coined his masterfulsomeness in mannerisms meditemptationed mullingarrisoned manifold. Was it here Swift and Stella cemented their Tristan and Isolde-like friendship?

Onward, a grey heron screeches angrily at the disturbance of his fishing rights by inconsiderate walkers, while mallard, chough, and water-hen panic exaggeratedly at human presence on their slumping banks. Our natural waterway unnaturally altered, electrically regulated, canalized and dammed, flows variably to sea through meadows manicured, where swan pairs nest and yearly raise broods of ten cygnets and more, if the foxes allow. Here fishing parties of credentialized cormorants trawl together the deep in co-operative, clandestine cabals and cadres, diving with grace and aplomb for trout and eel below the water-line. Above the herring-gulls and black-headed ones wheel amid the grey crows, magpies and the 'Richtofen-like' flying circus of the ravens and crows at their evensong of information-sharing gossip and power-flying, loudly, outrageously proclaiming their patterned superiority over their chosen flight-path – along the river.

Unseen are the countless rats, occasionally seen strongly swimming across Anna Livia's tide, close to the old names now renewed in the street-scapes: King's Hall and St Lawrence: midden and maiden: Artillery to Distillery: Knock Riada to Lucan's Esker – geomorphological gaelicizations! How much more appropriate than Coolmine Boulevard!

The bypass is a blessing for the village, restoring the calmer, sleepier atmosphere of an early Sunday morning. Population growth renews and enhances the experience of all in its environs due to its cultural diversity and in spite of its questionable architectural standards. There is still a necessary transience on the edge of city and country. This is slowly overcome as a more ancient identity of place begins to assert itself in this special setting, four miles from O'Connell's statue in the country's principal thoroughfare. With good community spirit and municipal wisdom, the quality of life lived here can but improve.

History teacher and musician

ON THE PHOTOGRAPHS IN *THE SHADOW OF JAMES JOYCE*

SHIGEHISA YOSHIZU

James Joyce once told a friend, 'I always write about Dublin, because if I can get to the heart of Dublin I can get to the heart of all the cities in the world.' He also said, 'I want to give a picture of Dublin so complete that if the city suddenly disappeared from the earth it could be reconstructed out of my work.'

I quite agree with the following description in *James Joyce: Reflections of Ireland* by Bernard McCabe and Alain Le Garsmeur (Little, Brown and Company, 1993, 8):

> In his last, extraordinary work, *Finnegans Wake* (1939), a vast all-night dream-sequence, written in dream-language, he celebrates a Greater Dublin which, while remaining recognizably itself, is endlessly tranformed into all the great cities of the world. Dublin's Hill of Howth becomes every mountain in the world; Dublin's River Liffey every river in the world; and Joyce's protagonists, a Dublin pub-keeper and his wife, by dream's magic, become that Hill and that River, and become archetypal Citizens of the World.

The photographs Motoko Fujita has taken in Chapelizod represent the artistic expression Joyce aspired to with the universal image of Dublin in mind. Her camera follows the scenes in *Finnegans Wake*, but her photographs are not mere ' illustrations' of Joyce's texts, just as McCabe describes Alain Le Garsmeur's photos in the above-mentioned book. Every frame of her photographs that pictures the landscapes, the buildings and the people may be different of time from those Joyce saw and captured. However, it seems to me that these photographs taken by Motoko are, as it were, the results of the scenes Joyce made eternally memorable in *Finnegans Wake*, having been re-illuminated by her.

So these pictures are the productions not of 'illustration' but of ' illumination'. This is the method of artistic expression used by the Celtic monks in transcribing the four gospels in the Bible and drawing their traditional patterns in colour, which resulted in the production of *The Book of Kells*. Those monks in their scriptoria tried hard to decorate and illuminate the holy text pages, especially the initial letters of verses.

In *Ulysses*, Joyce describes the word 'parallax' several times. This is a technical term used for the way an object looks different when viewed from different viewpoints, and Joyce uses this technique very often in the novel. Motoko also adopts this technique effectively in pointing her camera at an object. According to Joyce, as you know, a perception of the ordinary is changed into the extraordinary and significant; for instance, a trifling dialogue between the citizens suddenly signifies a profound and significant meaning to a listener. 'Epiphany' is his chosen word for such moments of vision borrowed from the Catholic tradition in which he was educated. Thus, my conclusion is that transformation, illumination and epiphany are the features of artistic expression deeply rooted in Celtic and Irish literature, as illuminated by Motoko's photographs.

Joyce scholar and Professor of Baiko Gakuin University, Japan

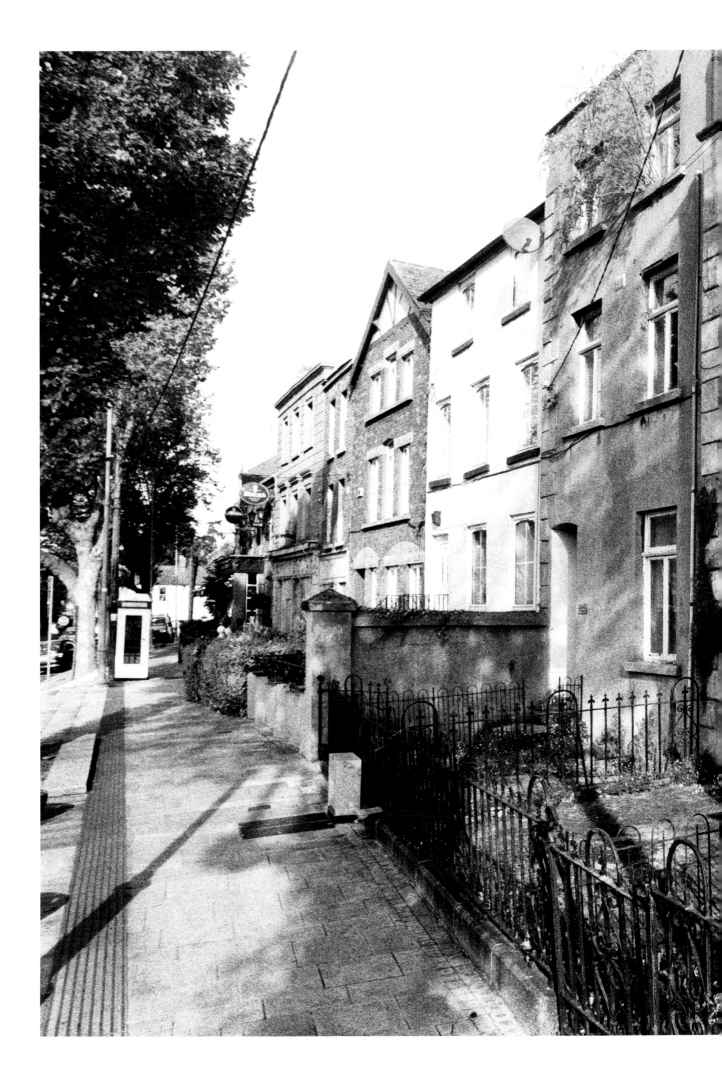

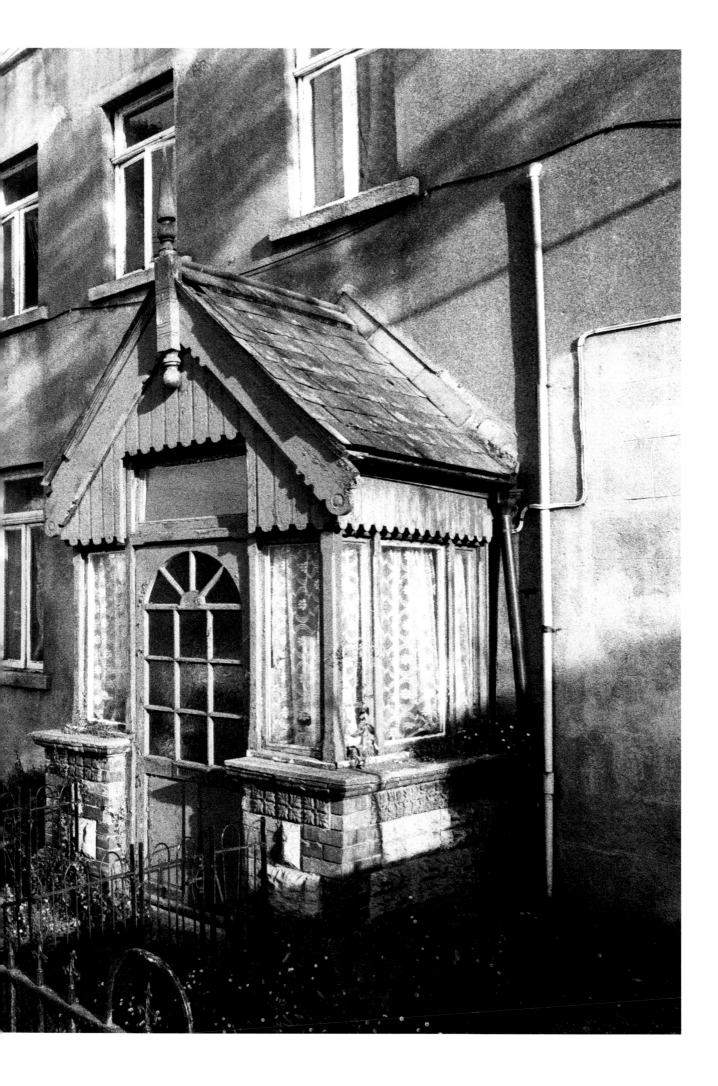

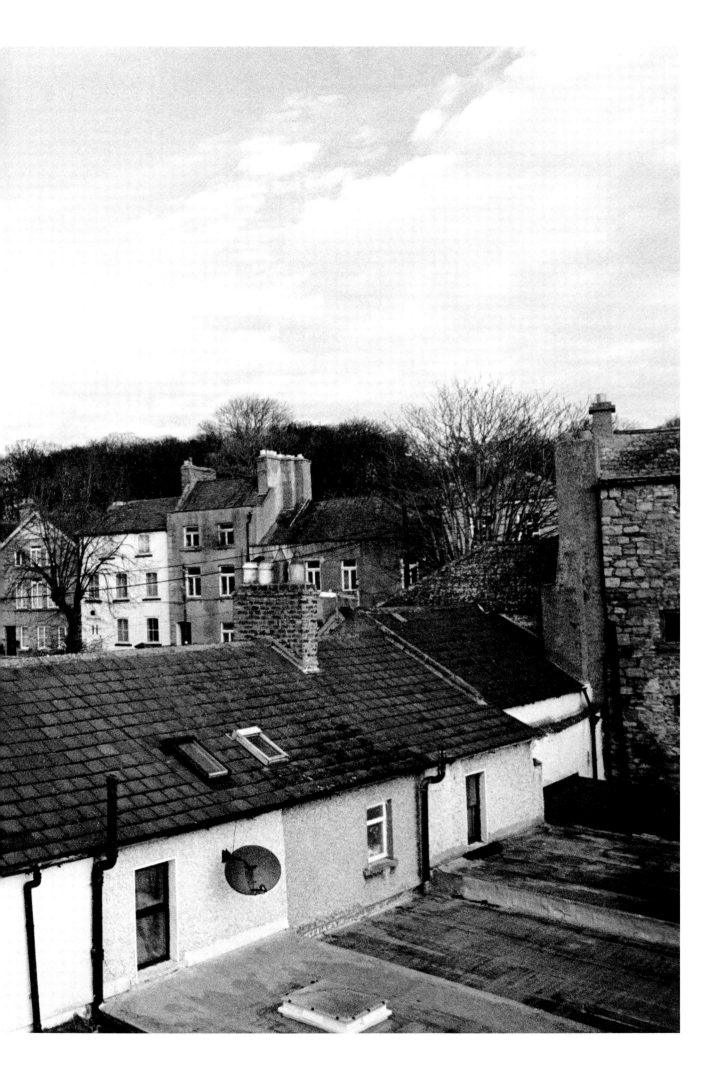

CAPTIONS

PART 3 INFUSION

謝　辞

　2007年に偶然、通りで出会って以来、友人パディ・ドネリー氏と私は、このチャペリゾッドという魅力あふれる小さな村をひたすら歩き回った。この企画は、私に写真と人生そのものを学ぶ機会を与えてくれた。それは、一度表現する勇気を失った私自身の、自己に向き合い、再び表現するためのリハビリテーションでもあった。パディは、手作りの杖と地域の歴史についての知識を持って、悪い足をかばいながらもご機嫌よろしく、私は、カメラと梯子を抱えながら、どこまでもどこまでも歩いた。藪の中を突っ切り、柵を越え、橋の下にもぐり込み、そしてついに、私たちはこの美しい村チャペリゾッドを、歩きつくしたのではないだろうか。

　見る、感じる、その“生”を捉える。私にとって、これが“写真を撮る”ということ。“一粒の砂に世界を見る”、その瞬間を求めてやまない。ジェイムズ・ジョイスのように、私も日本という母国を出た“放浪者”。偶然にも『フィネガンズ・ウェイク』の舞台となったこの村に住むようになった。今回の出版において、ご寄稿いただいた素晴らしいエッセイと共に、私が捉えたチャペリゾッドとジョイスの歴史というフィルターを通して、“普通”でありかつ“特別な”日常の、その現われ出る一瞬——ジョイスがその作品で表そうとした、平凡な物事の中に現れる啓示的な瞬間の再興を、少しでも皆さんと分かち合えることができたらと願っている。

　この企画を遂行する過程で、様々な方々のお力をいただいた。まずはすばらしい執筆者の方々、ラフィ・ドイル氏、トーマス・マックギラ氏、ウイリアム・マッコーマック博士、ジョン・マッカラン博士、バリー・マックガヴァン氏、デイヴィッド・ノリス議員、ダニス・ローズ氏、サム・スロート博士、そして、吉津成久教授に心より感謝申しあげたい。とりわけダニス・ローズ氏には、エッセイの編集に多大なご協力をいただき、また精神的にも支えてくださった。氏の、惜しみない専門的なアドバイスなしには、とてもこの企画を成し遂げることはできなかったと思う。また、恩師・吉津成久教授には、海を越えて、良き理解者として様々な面から支えていただいた。そして、別府大悟氏、ステイシー・ハーバート博士、トニー・オブライエン氏にも貴重なアドバイスを頂いたことを感謝申し上げたい。

　故パディ・ドネリー氏は、チャペリゾッドの歴史を実に詳しく語ってくれ、いつも辛抱強く、私が写真を撮り終えるのを待っていてくれた。彼の友情と励ましなくしては、この企画を続ける気力を維持できなかっただろう。また、故トーマス・マックギラ氏は、この企画を当初からサポートしてくださった。彼の賢明なアドバイスも、ここに至るまでの道のりを支えてくれた。今、大変に残念なのは、このお二人に直接、出来上がった本を手渡せないこと。2009年末から2010年初め、ほんの数カ月を隔てて、共に他界された。パディとトーマス、親愛なるケルトの友に、この本を捧げます。

　そして、企画の主旨を深くご理解いただき、出版資金のためのご支援をしてくださった、日本とアイルランドの後援者の皆様に心より感謝申し上げたい。

　出版にあたっては、リリパット・プレスのアントニー・ファレル氏とエリザベス・ヴァン・アマロンゲン氏にお世話になった。

　最後に、私の家族へ。ガレス（力強く支えてくれて、ありがとう）、愛玖と帆璃祝（写真ばかり撮っている母親に、我慢してくれてありがとう）、ジョンとクリス・デズモンド、そして藤田康彦、玲恵、佳江（企画進行の過程で、いつも心を共にし励ましてくれて、ありがとう）。

　そのほか、この本を完成させるためにご協力くださった全ての皆さん、感謝の念はとめどなく溢れてきます。本当にありがとうございます。

<div align="right">藤田需子</div>

Since we first bumped into one another on the street in 2007, my friend the late Paddy Donnelly and I have walked around this interesting grain-of-sand of history: Chapelizod village. This project has afforded me a chance to learn a lot about photography and about life itself. It was a kind of self-rehabilitation – having earlier lost the courage to face my own inner world – that allowed me to start again, to engage in self-expression. Paddy, hobbling merrily along with his handmade stick and his profound knowledge of the area, and I, chasing ahead, carrying cameras and a ladder, wended into bushes, over fences, under bridges and, at last, I think, into the heart of the lovely village of the Chapel of Isolde.

I see, I feel, and I capture 'the life'. For me, the special inner aesthetic emerges through the photographic process. To 'see a world in a grain of sand' is perhaps what I seek to do. Like James Joyce, I too am an exile from my home country, in my case Japan; so it is a coincidence that I should have ended up living in Chapelizod, the village in which he set his masterpiece *Finnegans Wake*. With this publication, alongside the fine essays included, I hope to share some images of my own, captured through the filter of Chapelizod's and of Joyce's history, pictures of ordinary and precious life taken in a moment of their standing out – an instauration or renewal of the epiphanic hidden in the commonplace such as Joyce achieved so magnificently in literature.

I should like in particular to thank the notable contributors to this project: Mr Raphy Doyle, Mr Thomas MacGiolla, Dr JW Mc Cormack, Dr John McCullen, Mr Barry McGovern, Senator David Norris, Mr Danis Rose, Dr Sam Slote and Prof. Shigehisa Yoshizu. Danis also helped me tremendously with the editing of the text and encouraged me mindfully as a friend: I doubt if I could have coped with this project without his liberal and expert assistance. Prof. Yoshizu, my former teacher, in diverse ways and from distant Japan, also gave me good and sustained support. My special thanks are also due to Mr Daigo Beppu, Dr Stacey Herbert and Mr Tony O'Brien.

Paddy Donnelly related to me in great detail the history of the area and, time after time, patiently waited for me while I was taking my shots. His friendship and encouragement kept me going through many an otherwise bleak day. Also, I owe a debt to the late Mr Tomás MacGiolla, who supported this project from its inception. Without his wisdom, I would have achieved far less. I truly appreciate their support. The only regret I have now is that I can't deliver this book directly into the hands of these old gentlemen. This book, nevertheless, is dedicated to them: to Paddy and Tomás, my dear Celtic friends. I miss you both a lot.

I should like to thank also all those sponsors from both Japan and Ireland who have helped to fund this publication.

In the publication process, my special thanks are due to Mr Antony Farrell and to Ms Elizabeth van Amerongen at the Lilliput Press.

Lastly, I owe special thanks to my family: to Gareth (thank you for giving me some bright ideas and a great support); to Aiky and Holly (thank you for being patient with your mother who can't stop taking photographs); to John and Chris Desmond; and to Yasuhiko, Tamae and Yoshie Fujita (thank you for being with me and cheering me up so much during this work in progress).

And to everyone else who helped in the completion of this book, no brief word could be good enough to express my appreciation, even so: thank you so much.

Motoko Fujita

SPONSORS

Tatsuya Akitake, Japan

Anzen Akiyama, Japan

Sachiko Arima, Japan

Toshiko Ariyoshi, Japan

Baiko Gakuin University, Japan

The Bridge Inn, Ireland

Canada-Japan Friendship Association, Japan

David Farrar, Japan

Dublin City Council, Ireland

Hiroko Fukumoto, Japan

Masako Fujita, Japan

Tamae Fujita, Japan

Tetsuo Fujita, Japan

Yasuko Fujita, Japan

Yoriko Fujita, Japan

Takao Gyoji, Japan

Kimiko Hitsumoto, Japan

Yasunori Honda, Japan

Yuka Iino, Japan

Satoru Ikeda, Japan

Natsuhiko Imai, Japan

iophotoworks, Ireland

IPN Photography Agency Services C/O Helen Burke, Ireland

Masato Iwata, Japan

Miyuki Izumisawa, Japan

The James Joyce Centre, Ireland

The James Joyce Society of Japan

Japan Bytes Ltd., Ireland

The Japanese Culture Club, Ireland

Masami Kashiwagi, Japan

Mariko Kawabata, Japan

Rin Kawata, Japan

Miwa Koezuka, Japan

The Liffey Valley Park Alliance, Ireland

In commemoration of Mr Paddy Donnelly's great work for the group over the years

Asa Makino, Japan

Nozomi Mimura, Japan

Shinobu Minma, Japan

Kunio Muraoka, Japan

Shinji Nakano, Japan

Masanori Nagaoka, Japan

Katsuji Niki, Japan

Office of Public Works, Ireland

Ordnance Survey, Ireland

Oishii Foods Ltd, Ireland

Yoshihiro Ogino, Japan

Yoshino Ohno, Japan

Kazuko Oka, Japan

Minako Okuda, Japan

Aying Patterson

Minako Otani, Japan

Tadashi Sadamatsu, Japan

Tsuyoshi Sakono, Japan

Chieko Sakono, Japan

Chizuru Sakono, Japan

Osamu Sakono, Japan

Yoku Sakono, Japan

Kaoru Sato, Japan

Yasumasa Sato, Japan

Shimonoseki Shiritsu Daigaku, Japan

Tomie Shintomi, Japan

Etsuyo Shirai, Japan

Kazuko Suekuni, Japan

Yoichiro Takahashi, Japan

Kaori Tanaka, Japan

Kazuko Tokunaga, Japan

The Villager, Ireland

Awaji Watanabe, Japan

Ryuichi Yamashita, Japan

Mami Yoshida, Japan

Shigehisa Yoshizu, Japan

Toshiko Yoshizu, Japan

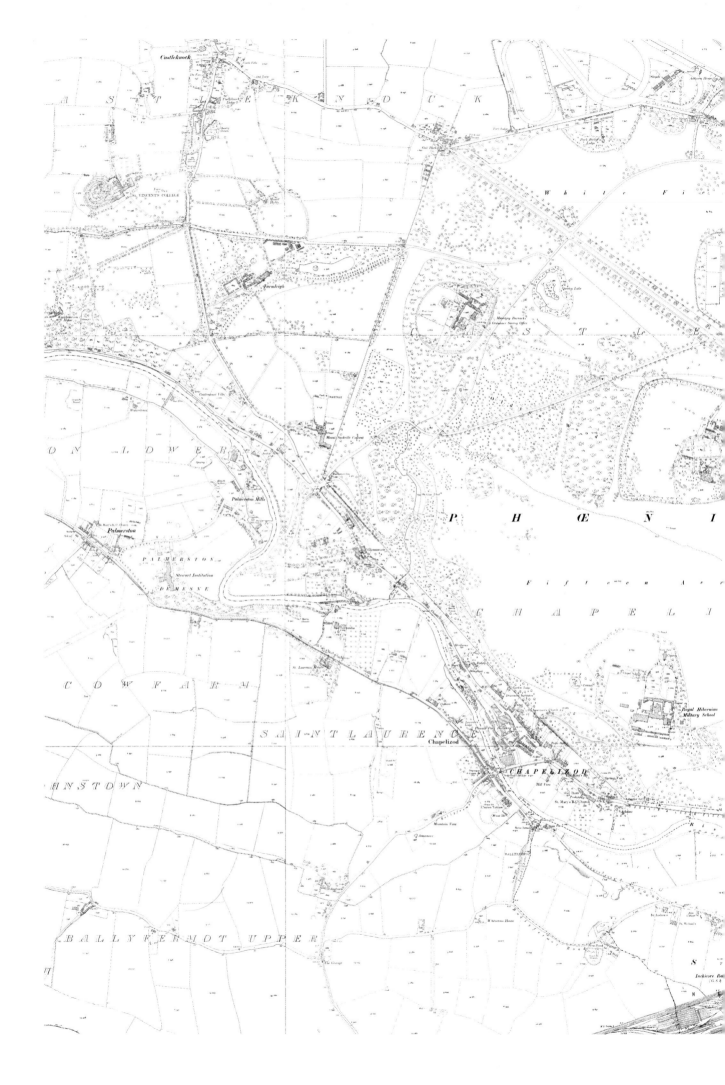

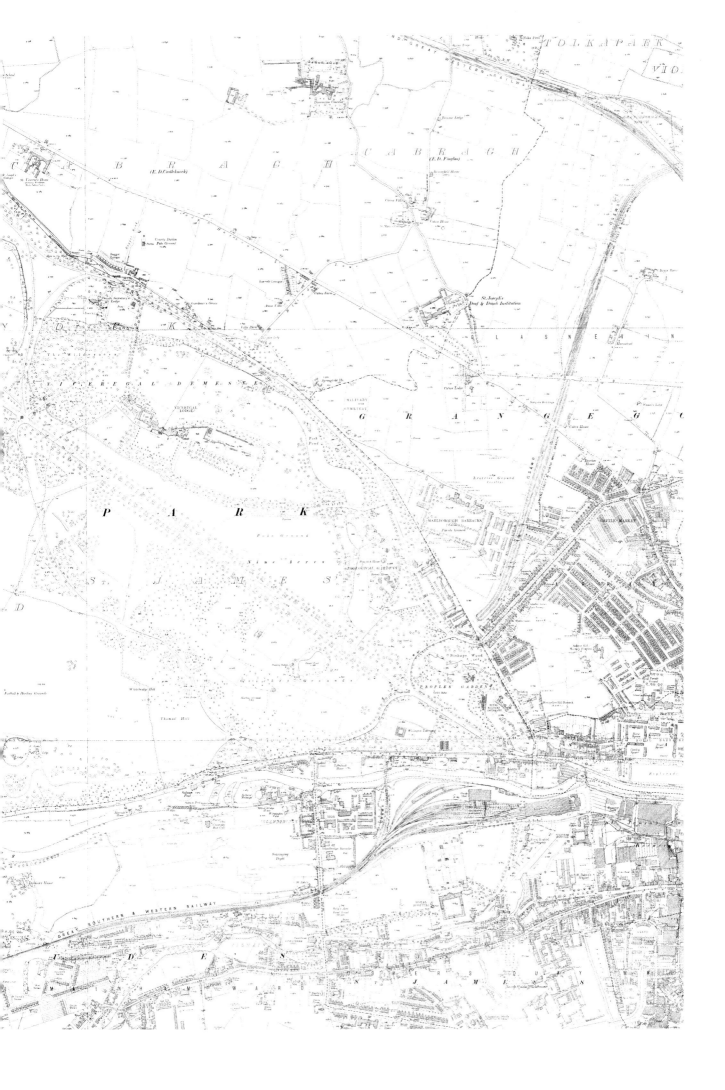

PROFILE

　藤田需子（ふじたもとこ）と彼女が愛用するカメラは、どちらも日本製。福岡市在住時に、通りを歩き回る野良犬たちを記録するために写真を撮りはじめる。以降、ポートレイトから風景、広報から抽象まで、あらゆる方面の写真にチャレンジ。2003年初頭、ダブリンに移ってからは、ミュージック・フォトグラファーとして活動。地元のアイリッシュ・バンドはもとより、ザ・オーブ、アンディ・ルーク（ザ・スミス）、マニ（プライマル・スクリーム）、ユース、そしてアルフィーなどを撮影。バンドのイメージ写真は、その音楽性が最も良く表現されるように、自身で選んだ場所でコーディネートし、独自性を出す。

　下関市の梅光学院大学在修士課程在学中、アイルランド人作家ジェイムズ・ジョイスについて学ぶ。アイルランドに移ってからは、古風な趣の残る、ジョイスゆかりの村チャペリゾッドに魅かれ、村の風景を撮り始める。この二つの経験が、『ジェイムズ・ジョイスの影』の企画・制作へと繋がる。

　2010年夏、NHKの取材を受け、フォトグラフィック・アーティストとして、その作品が紹介される。また、故郷下関市にある二つの大学で、自身の写真体験談を語る。

　チャペリゾッドでジャパニーズ・カルチャー・クラブを設立し、アイルランドの魅力を日本に紹介している。2010年4月、ダブリンで初のジャパニーズ・デイを企画。このイベントは、国立公園フェニックス・パークで行われ、2万人以上の観衆を集めた。

MOTOKO FUJITA and her camera are both 'made in Japan'. She started taking photographs to record stray dogs found roaming the city streets of Fukoaka in Japan. Since then she has consistently challenged herself in all areas of photography: from portrait to landscape, from press to abstract art. From early in 2003 she has been based in Dublin, working mainly as a music photographer. She has photographed *inter alia* The Orb, Andy Rourke (of The Smiths), Mani (of Primal Scream), Youth and Alfie, as well as Irish bands. She personally directs each shoot, coordinating and individuating her unique photographs to best reflect the bands' music.

At Baiko Gakuin University (MA), Shimonoseki City, Japan, Motoko studied James Joyce. Upon moving to Ireland she was attracted to the old world aspect of Chapelizod and quickly began to capture images of the village. These and others have led directly to her work *The Shadow of James Joyce*.

Motoko has appeared on NHK (Japan's national television station) in a feature about her work as a photographic artist. She has also given lectures in universities in her hometown, Shimonoseki City, describing her life as a creative photographer.

Motoko is chairperson of the Japanese Cultural Club (JCC) in Chapelizod and has been active in introducing Ireland to a Japanese audience. She conceived and realized the first Japanese Day at the Phoenix Park in Dublin in April 2010, an event attended by more than 20,000 visitors.